IMAGES
of Modern America

BRIDGES OF DOWNTOWN LOS ANGELES

2018

Patricia Delicia,

Let's keep building beautiful bridges, linking our hearts.

¡Feliz cumpleaños, Querida!

Pedro xoxo

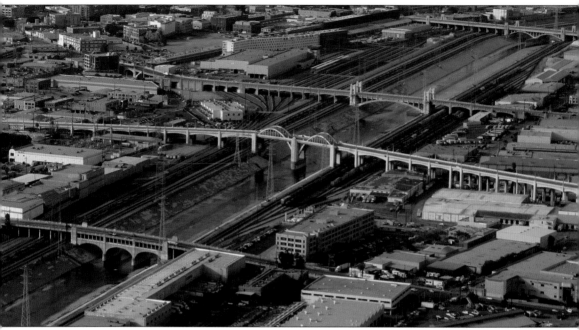

This aerial view depicts four bridges in downtown Los Angeles. From the top are First Street bridge; Fourth Street bridge; Sixth Street bridge, with its double arches; and Seventh Street bridge at bottom. The Seventh Street bridge is literally one bridge built atop another, visible as what appears to be a row of windows below the main deck. (Photograph by author.)

On the Front Cover: Clockwise from top left:
Broadway Viaduct (Photograph by author; see page 25), close-up of Sixth Street bridge (Photograph by author; see page 67), Sixth Street bridge (Photograph by author; see page 66), Olympic Boulevard Viaduct (Photograph by author; see page 84), Sixth Street bridge (Photograph by author; see page 68)

On the Back Cover: From left to right:
Fourth Street bridge; Sixth Street bridge, with its double arches; and Seventh Street bridge (Photograph by author), aerial view of downtown Los Angeles's bridges (Photograph by author; see page 2), close-up of Sixth Street bridge (Photograph by author; see page 71)

IMAGES
of Modern America

BRIDGES OF DOWNTOWN LOS ANGELES

Kevin Break

ARCADIA
PUBLISHING

Published by Arcadia Publishing
Charleston, South Carolina

Printed in the United States of America

Library of Congress Control Number: 2014959600

For all general information, please contact Arcadia Publishing:
Telephone 843-853-2070
Fax 843-853-0044
E-mail sales@arcadiapublishing.com
For customer service and orders:
Toll-Free 1-888-313-2665

Visit us on the Internet at www.arcadiapublishing.com

This is dedicated to Eric Delony, a world-class expert on bridges, who inspired me to write this book with his kind encouragement and personal interest. Thanks, Eric!

CONTENTS

ACKNOWLEDGMENTS

The Los Angeles Public Library (LAPL) has graciously opened its archives and lent assistance. A thank-you is owed to the Friends of the Los Angeles River for its support. This publication would not have been possible without the help of the City of Los Angeles Bureau of Engineering and the Los Angeles Conservancy.

INTRODUCTION

Los Angeles has long shared an uneasy truce with the river that bears its name.

For millennia, the Los Angeles River has trickled down from the San Gabriel Mountains to the coast, occasionally flooding during storms. Some of the floods have been huge, consuming, violent, and unstoppable.

Large and apocalyptic storms have actually altered the river's course and mouth, sometimes by many miles. Within living memory, the mouth of the Los Angeles River has moved from Santa Monica to Long Beach, a distance of about 30 miles. It has been said that the entire Los Angeles Basin is the natural floodplain of the river.

During the population explosion of the last century, enough lives were lost and property damaged, that the effort was made to tame the sometimes wild river. This was done by digging a deep streambed and then paving it with concrete.

While aesthetically distasteful to some, the stolid concrete channel has served its purpose well. There has been no major flooding near the course of the river nor many lives lost ever since. Most people do not know that more people have died from floods in Los Angeles than from earthquakes.

The early growth of Los Angeles was hampered and constrained by the river running through the center of the city. Large, newsworthy floods occurred roughly every four to five years in the 19th century, as well as in the beginning of the 20th century, cutting off Los Angeles from railroad commerce, telegraph, telephone service, and, of course, road connections to the rest of the country. The existing bridges also were washed out, halting railroads and the real estate markets. There were no freeways in those days, but they would have suffered the same fate.

In the early part of the 20th century, floods destroyed parts of movie studios and also caused serious fires. One flood isolated the entire Van Nuys area for a week. About 100 bridges in Los Angeles County have been destroyed by the river.

Los Angeles had begun its long struggle to understand, contain, and, perhaps, restore the river someday.

The first bridges, mostly built by the railroads and local commerce, made flooding worse. They usually were of wooden, X-shaped trestles, which caught river debris. As the debris built up during flooding, the bridges acted as dams and soon failed.

In addition to the poorly engineered bridges, many people insisted on buying and building on land close to the river's streambed; however, their folly became evident with time.

As the issue aggravated, both the city and the railroads turned to more permanent concrete and steel construction. These bridges also washed away; their abutments and piers were undermined by the swirling floods.

As the city grew and prospered, the problems with the bridges became acute. Traffic is and was a permanent "feature" of Los Angeles, but it was always much worse in the downtown core before the current bridges were built. Using the "carrot and stick" approach, the city was able to convince and coerce the railroads into helping fund bridges that would go over the tracks instead of intersecting the tracks. This was a huge relief to both the railroad and the commuters. They also had much larger and deeper foundations, which proved to be sufficiently resistant to floods.

Many Angelenos who are not as well acquainted with the riverine flow forget there is even a river at all! Contrary to belief, the river is never completely dry. In modern times, the rain raises the river by only a foot or two. During storms, for just a matter of hours or minutes, the river swells. Its depth can vary from a few inches to about 8–12 feet, which the author has witnessed, in just a few hours.

During the course of one day, a person could walk safely in the riverbed in the morning yet be swept away to almost certain death by the time evening comes.

On at least two occasions, the measured river flow has met or exceeded the flow of the mighty Mississippi River at its mouth.

Some of the heaviest precipitation ever recorded in this country has been at the river headwaters in the San Gabriel Mountains.

While quiescent for most months and even entire winters, the river at its height is nothing to be trifled with. While the Mississippi River drops 600 feet over its course of 2,000 miles, the Los Angeles River drops 800 feet in only 50 miles! This means the water gains inertia quickly and continues to accelerate all the way to the ocean.

At first, early bridges were built too low to the river, made too short, made of wood, and were wholly inadequate. A number of levees were built, usually forcing the river against the opposite bank, moving the flood damage to the other side. This led to sabotage and recriminations, a loss of any flood control, and then inevitable deaths and loss of property. Some people tried to "train" the river by moving boulders and wooden debris so the river would cut a new, deeper channel where they deemed fit.

All of this was not working out, and the situation cried for a resolution.

Our ancestors did find their solution, and it did work and still does. It may not appeal to many who would like to have the river in a more natural state, but the chaos has ceased for many decades now.

First, new, solid, technologically advanced viaducts were built in the downtown area up to the San Fernando Valley near Glendale. Soon after these new and still-existing bridges were constructed, the river itself had its course defined, dug out, deepened, and then finished in concrete. It is a good idea to define terms here. A "bridge" is a man-made extension of a road, over water. A "viaduct" is a man-made extension of a road over both land and water. By raising the bridges and extending their grade over land, they could then accommodate rising flood waters, their ends located many yards from the river.

During this time of taming the river, 14 dams were built upstream and countless debris-catch basins and several flood-control basins somewhat akin to dry lake beds were constructed.

Whether the reader loves or abhors the work of the US Army Corps of Engineers, it must be admitted that they discharged their duty with excellence. The Los Angeles River no longer is a threat to life, property, and commerce.

Perhaps with skill and understanding (and a learning experience or two), the river can have portions restored to something like its original, natural state for the enjoyment of all.

Now, we will explore the crown jewels of the Los Angeles River, its downtown bridges.

During the 1920s and 1930s, the river became strictly defined and constrained to the maximum in the city center. Ten monumental bridges were built there in this short duration. Three other bridges built in the area were retained and upgraded, and several are still being upgraded at the time of this writing.

From north to south, the bridges on the Los Angeles River are as follows:

Fletcher Drive	1927
Hyperion Avenue	1929
Riverside Drive	1939 (included due to proximity)
Spring Street	1929
Broadway Place	1911
Main Street	1910
Macy Street (Sunset Boulevard)	1926
Aliso Street (101 Freeway)	1940 (included due to proximity)
110 Freeway	1941 (included due to proximity)
First Street	1929
Fourth Street	1929
Sixth Street	1932
Seventh Street	1927
Olympic Boulevard	1925
Washington Boulevard	1931

One

FLETCHER DRIVE AND HYPERION AVENUE VIADUCTS

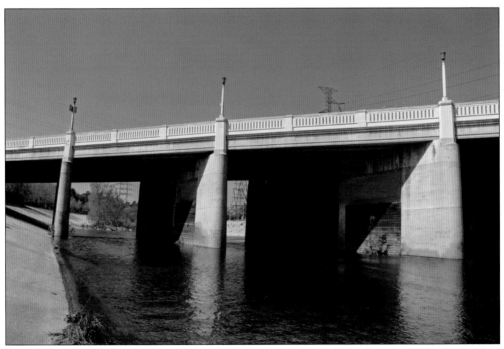

Merrill Butler, who was responsible for the design of many of the bridges in this book, finished the Fletcher Drive Viaduct in 1927. Fletcher Drive Viaduct was upgraded seismically in 1992 and again in 2012. This bridge carries much of the traffic between the Los Angeles neighborhoods of Silver Lake and Atwater. This viaduct also has an exuberant number of pylons—six—to hold it over the river. (Photograph by author.)

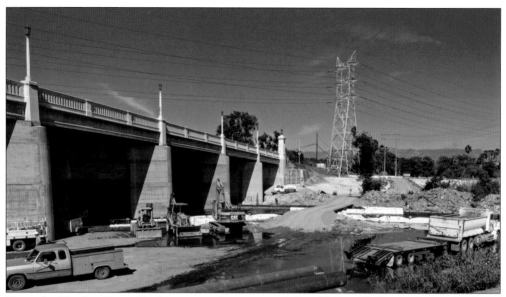

Here, the Fletcher Drive Viaduct is seen being upgraded in 2012, with foundation and column work. Note how the river's water has been diverted. Fletcher Dive, one of the busy surface streets connecting Los Angeles with the neighboring city of Glendale, was designed to be a major thoroughfare and has enjoyed quiet success for many years. (Photograph by author.)

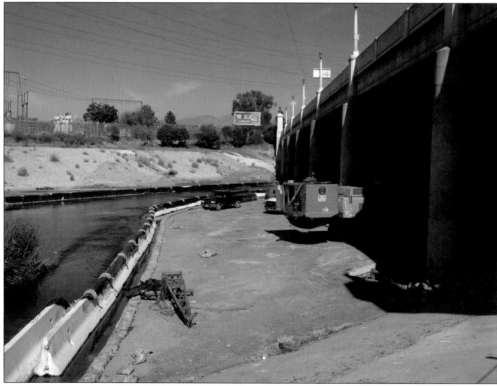

Here is the upstream view of the Fletcher Drive Viaduct during 2012. One can see how the river was diverted with K-rails and sandbags. (Photograph by author.)

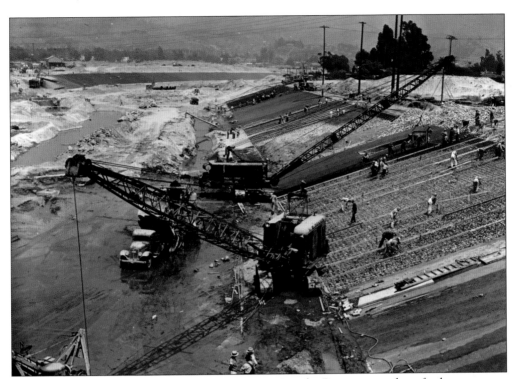

Multiple floods finally led to the paving of the Los Angeles River, as seen here farther upstream in the late 1930s. (Courtesy of the Library of Congress.)

This special daytime time-exposure hides the vehicle traffic to reveal the bridge structure; happily, it is wide enough to permit a freeway under its largest spans. While the other bridges span water, this one spans over 300,000 cars daily. (Photograph by Brian Grogan; courtesy of the Library of Congress.)

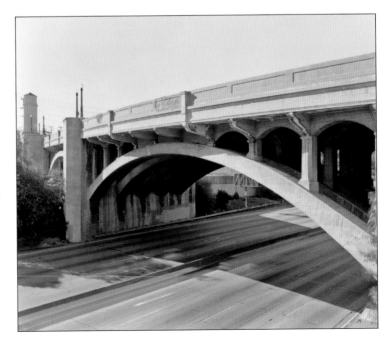

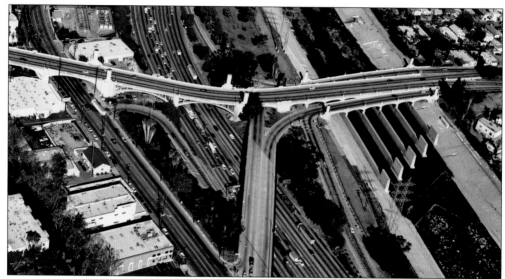

This 2001 aerial view of Hyperion Avenue shows how complicated this bridge is. Two viaducts, one on either side, bring street traffic to and from the north side. Downstream, the long-removed streetcar bridge still shows its support pylons. At center is the Interstate 5, to the left is Riverside Drive, and at center bottom is Glendale Boulevard. (Photograph by Brian Grogan; courtesy of the Library of Congress.)

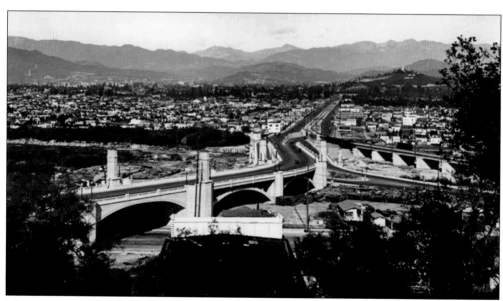

This view of Hyperion Avenue is hard to see nowadays as the trees have grown up and much of the land is now privately owned. Of interest is the intricate approaches to the bridge on the right, with the now-vanished streetcar bridge at far right. The two large arches now contain the Interstate 5. Los Angeles was fortunate the freeway fit inside. Riverside Drive is in the foreground, and to the right and out of view, it ends up at the Riverside Drive bridge. (Courtesy of LAPL.)

Two

RIVERSIDE DRIVE AT
FIGUEROA STREET

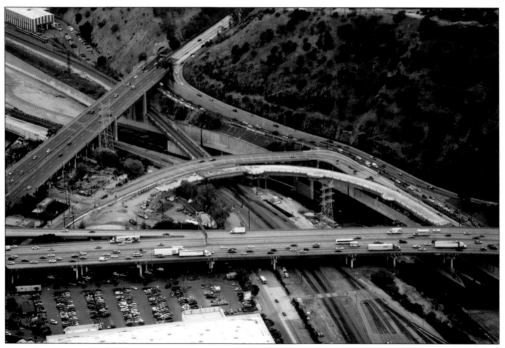

Here is a 2013 aerial photograph of the new Riverside Drive bridge and the old one before it was demolished. In the foreground is the Interstate 5. Above that, the white curve is the new bridge with the separate railroad section being finished, and above that is the old bridge with the sharp 90-degree bend where accidents occurred. At top is the 110 Freeway and the 110 and the Interstate 5 interchange. Now the old bridge is gone, and the new one is currently getting its third lane added. At the orange-lit tunnel at top, left of center, is the spiral staircase mentioned at the end of this volume. (Photograph by author.)

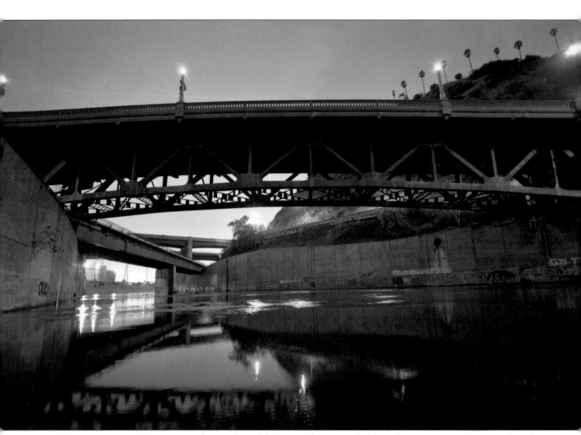

This evocative 2007 image shows the old Riverside Drive bridge that most readers are familiar with. This night shot portrays the river as placid and still, not like during the winter storms. As always, the sound of night birds echoes across the riverbanks. (Photograph by author.)

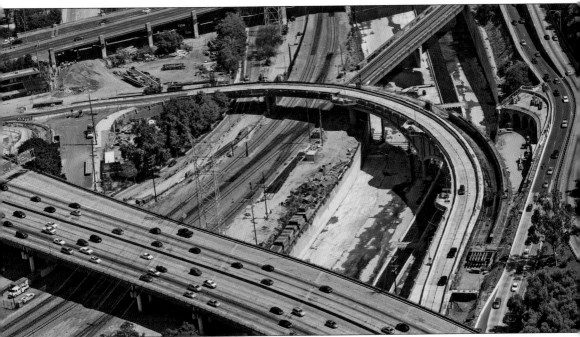

This image of the new Riverside Drive Viaduct from May 2015 shows the new and final third lane coming together over the river; on the right can be seen the last corner of the 1929 bridge, cut off at the catacombs. The green bridge at top is Midway, pointing at the spiral staircase out of view. At bottom, the Interstate 5 intersects with the 110 Arroyo Seco Parkway, the first freeway in the world. This new bridge is a radical departure from the stylish bridges of the last century. (Photograph by author.)

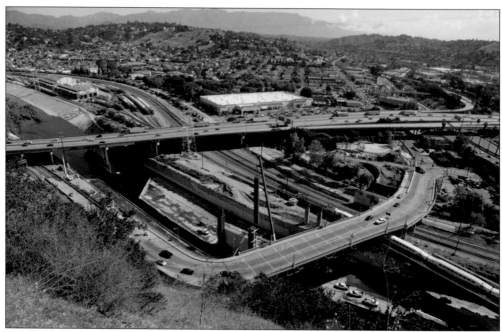

This hillside view is the converse of the image found on page 13. This 2013 photograph shows a rebar cage being dropped into a pylon in the center of the river to support the new bridge. Columns for the new Riverside bridge can be seen next to the Metrolink train right of center. At top, the Interstate 5 cruises from left and right. (Photograph by author.)

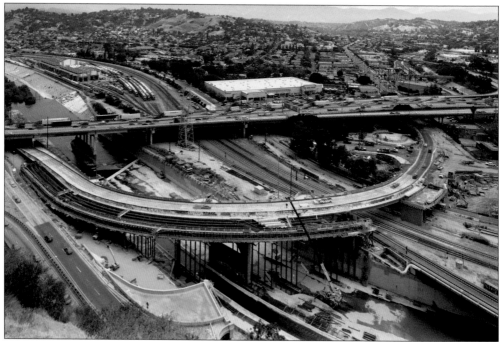

This same view in 2015 shows the form of the new Riverside bridge revealed. The constant radius curve should reduce accidents and increase speed. At top, the Home Depot in Cypress Park watches the progress. (Photograph by author.)

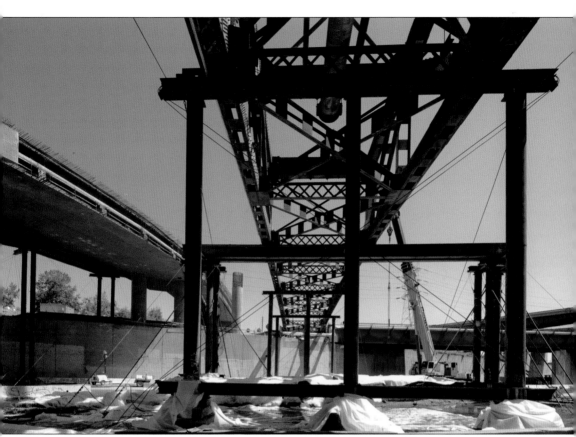

This magnificent image shows the demolition of the old Riverside Drive bridge well under way in the summer of 2014. The roadway is entirely gone, showing the old-style truss work underneath. At left, the new viaduct grows. (Photograph by author.)

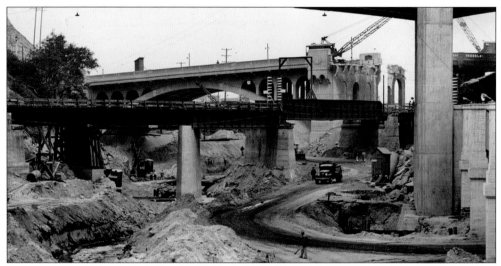

Here is part of the huge cleanup after the 1938 flood. In the background, the 1929 Riverside Drive Viaduct is being demolished; in the foreground, the railroad bridge is once again taking shape; and above is the 110 Freeway. There have been three bridges named Riverside at this location in the past century. (Courtesy of the Bruce Petty Collection.)

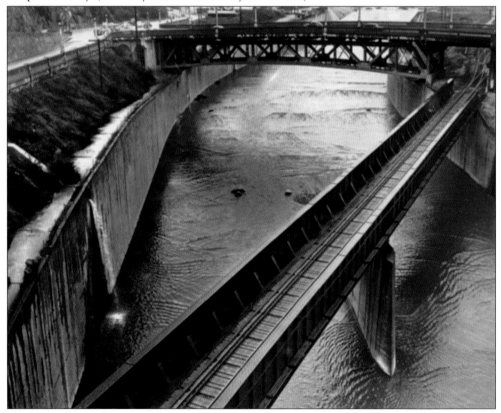

Here is the view after the cleanup, during a 1941 rainstorm. Now, the old concrete 1929 bridge has been replaced with an old-style girder bridge, presumably for being quick and inexpensive to construct. This 1939 viaduct lasted until 2014. (Courtesy of the Bruce Petty Collection.)

Here is a close-up of the severe damage to the Riverside bridge after the 1938 landslide. (Courtesy of LAPL.)

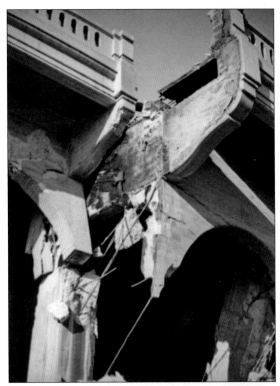

This gorgeous scan shows the other side of the 1929 Riverside Drive bridge, and behind it is a glimpse of the old Dayton Street bridge, which was removed and not replaced. (Courtesy of the Bruce Petty Collection.)

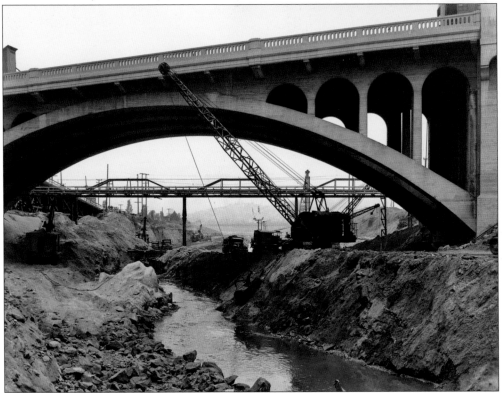

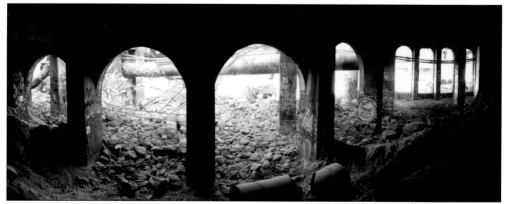

This is a ghostly view of the 1929 Riverside Drive bridge catacombs during demolition in 2014. Happily, this part of the viaduct looks as if it will survive the completion of the new bridge. Generations of local kids have played here and tagged the walls, and the ceiling is stained black from countless cooking fires. (Photograph by author.)

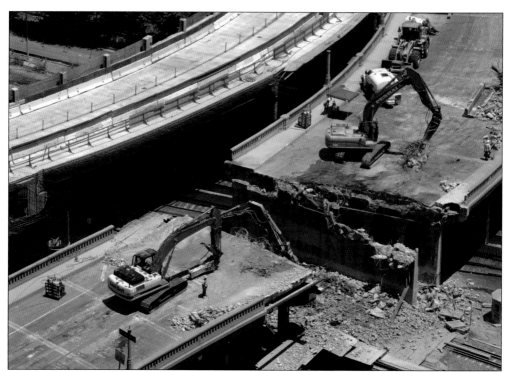

This fascinating view from the summer of 2014 shows the demolition of the previous 1939 Riverside bridge (1939–2014). At top, the new bridge progresses. At bottom, a delicately timed closure of the railroad tracks permits demo of the "bents" over the rail right-of-way. (Photograph by author.)

Three

Spring Street and Broadway Viaducts

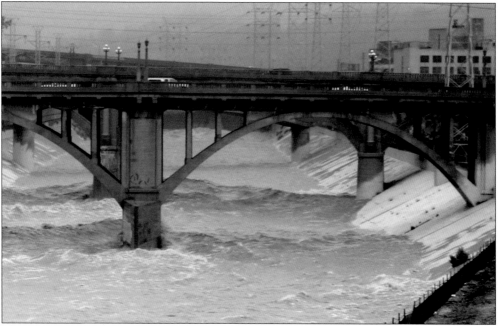

This 2007 photograph of the Spring Street bridge (in front) and Broadway bridge (in back) illustrates exactly why the Los Angeles River was paved. This storm had waves cresting to 15 feet/5 meters, with an average of 12 feet/4 meters. The river sounds like thunder during storms, and mist covers everything in the proximity. Note that the Broadway Viaduct had been totally rebuilt by 2000. Looming in the distance on the right is the old Los Angeles City Central Jail. (Photograph by author.)

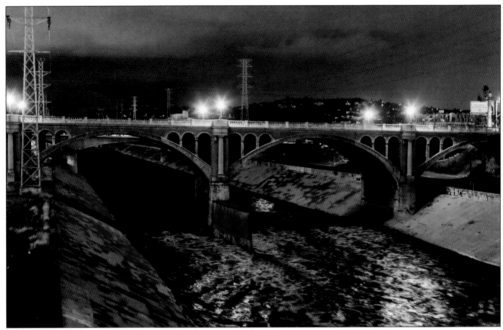

Here is an image of the Broadway Viaduct after a storm. At the time of construction (1909–1911), Broadway was the largest concrete arch in California and one of the largest in the country. It was huge for its time at almost 970 feet/295 meters long and was a high-tech marvel with its open-spandrel ribbed arch, which had been in use only two years. Broadway is the oldest of the bridges in this collection, and to keep the bridges over the rail crossings instead of through the crossings, the railroads partially paid for the Broadway bridge. Broadway served as the prototype design for all the bridges in downtown Los Angeles. Its sister bridge, Spring Street, is obviously based on Broadway but without the ornamentations (and budget). (Photograph by author.)

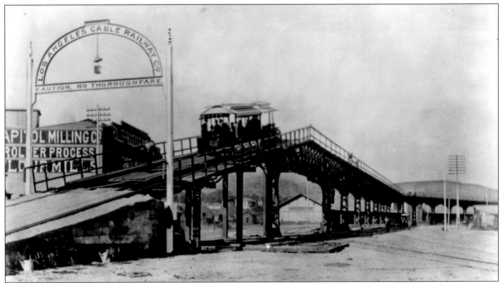

This very old view is where the Broadway, or Buena Vista, bridge first started. This location is in Chinatown at the west end of Cornfield State Park. The milling building at far left is still standing. In later years, the bridge was rebuilt and moved to its current location. (Courtesy of LAPL.)

This very old view is of one of the older bridges preceding the current concrete Spring Street bridge. One can see how these fragile structures could be washed away. Right of center is a group of men atop the bridge. (Courtesy of LAPL.)

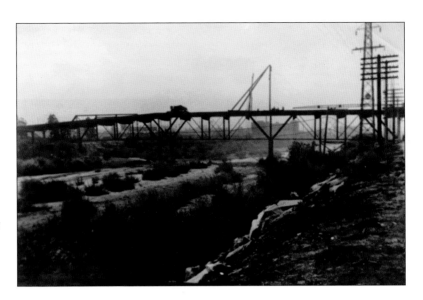

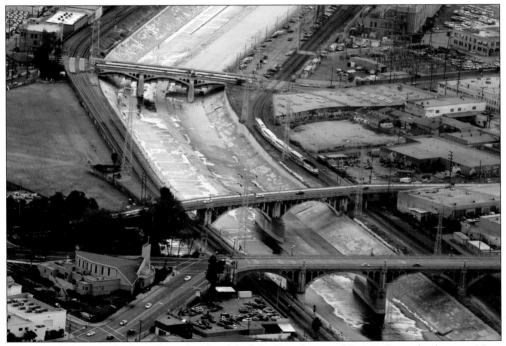

This aerial photograph shows how closely related the Broadway and Spring Street bridges are. Note the two roads converge at the left. Downstream is the Main Street bridge, which will be explored later. Broadway was built in 1911 and is one of the more ornate bridges in this collection. Some details, like columns and streetlights, were lost over time but have been restored to something akin to their original appearance when the bridge was rebuilt at the end of the 20th century. (Photograph by author.)

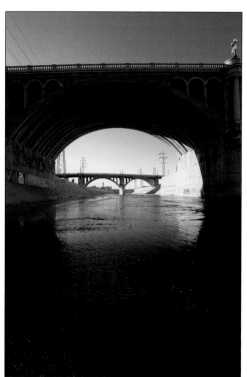

Here is Broadway bridge framing a view of the Spring Street bridge during the spring of 2007. The water level is about an inch deep. Even at this depth, the river supports numerous small fish, birds, and tadpoles. (Photograph by author.)

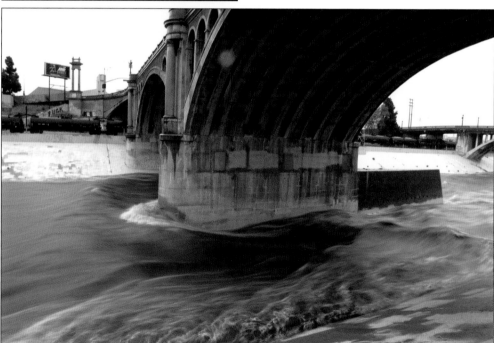

This view during a 2012 storm shows the central pylon of Broadway with the fin on the downstream side, unlike all the other bridges which have fins upstream or on both ends. Water depth is over a person's head. Rain does not show up in time exposures, yet note the drop of rain that clings to the top center of the frame. (Photograph by author.)

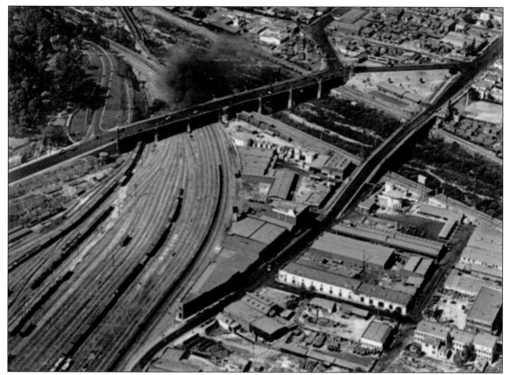

Here is another unique aerial photograph. This northeast-looking photograph depicts sister bridges Broadway and Spring Street. At left, traffic moves from Chinatown over the unpaved river into Lincoln Heights. At bottom left, the Cornfield is filled with now-gone railroad tracks. At bottom right, many of the industrial buildings still exist. Note the smoke under Broadway. Its source is unidentified but could have been due to trains. (Courtesy of LAPL.)

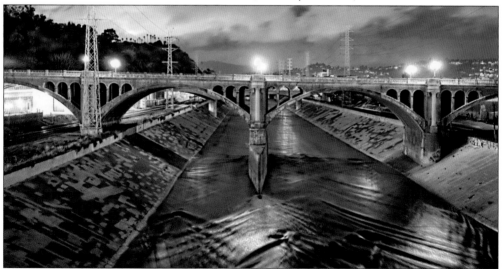

This night image shows the Broadway Viaduct after a storm. The Beaux-Arts style is clearly visible in this photograph; this design carries ornamentation that includes columns, pylons, balustrades, and streetlights. This viaduct was the longest and widest concrete bridge in the entire state when completed. Later, Sixth Street would take that title in the 1930s. (Photograph by author.)

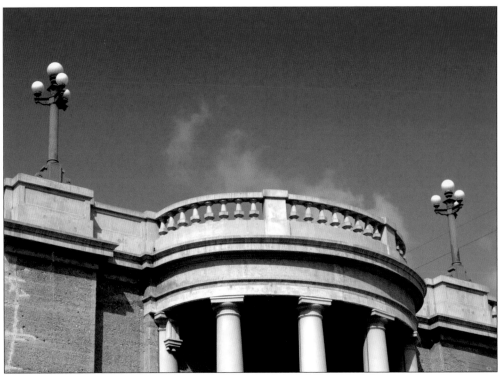

This is a detail shot of Broadway's portico, balcony, balustrade, and streetlights restored in 2000. (Photograph by author.)

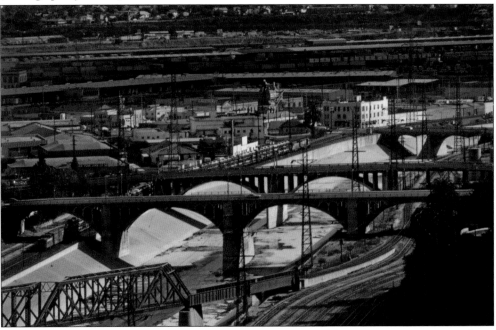

This 1960s–1970s photograph was taken from Elysian Park and depicts Main Street, Broadway, Spring Street, and a railroad bridge, which has since been replaced by a single-span concrete bridge. A trainload of new cars is heading down the tracks. (Courtesy of the Bruce Petty archives.)

This is a detail shot of one of Broadway's four pairs of freestanding columns. They are quite tall; people cannot touch even the bottom of the columns. This pair is at the southeast corner near the entrance to Elysian Park, home of the Dodgers. (Photograph by author.)

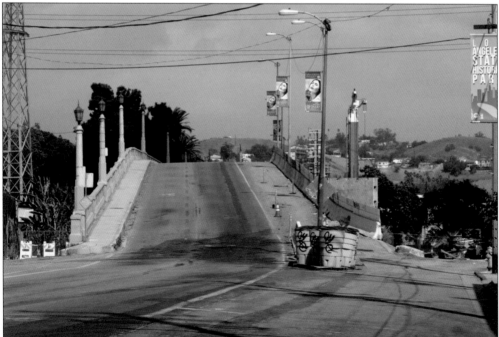

This northeast-looking view of Spring Street shows how steep the arch is and how unfriendly this bridge is for pedestrians. Spring Street never had a sidewalk on both sides. The current upgrade should fix this as well as adding a lane. On the right side, one can see the top of the blue crane working in the river on page 32. (Photograph by author.)

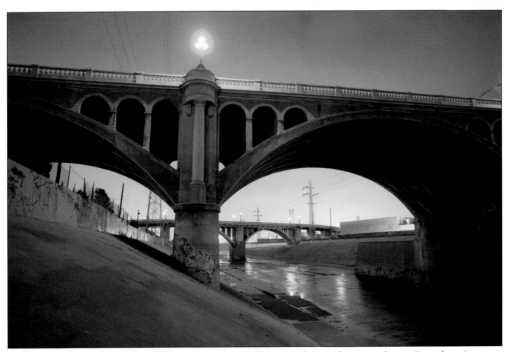

This night view shows Broadway's ornamentation in front and reveals how sparse Spring Street is in the background. Spring Street bridge was built several years after Broadway to siphon off some of the traffic burden. At rush hour in the evenings, Spring Street and Broadway are bumper to bumper. Both bridges have open spandrels. (Photograph by author.)

This photograph, taken from a belvedere in downtown Los Angeles, shows the Broadway's resurrected streetlights from the 1990s restoration. (Photograph by author.)

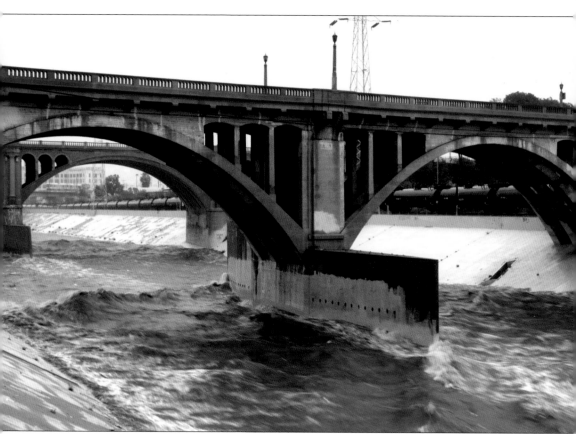

Here, Los Angeles River is at flood stage. Looking at the drain holes in Spring Street's pier, one can see that the river is about six feet/two meters deep. Mist hangs in the air, and the sound is enveloping, making it difficult to hear. Upstream is Broadway bridge. At the time of construction, the railroads were interested and participated in the bridge design. The railroads wanted as little road interference as possible, resulting in grade separations, which are call viaducts. (Photograph by author.)

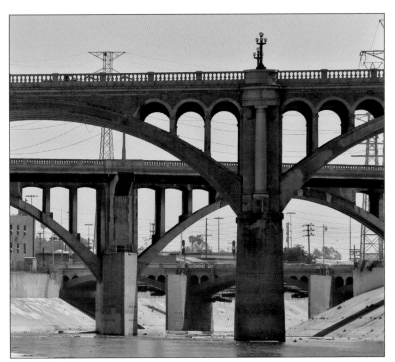

This 2015 photograph, more than any other, shows how similar Broadway and Spring Street bridges are. Though the Spring Street bridge is less ornate than the Broadway bridge, one thing it does have over its sister bridge is an upstream fin. Bringing up the rear, Main Street has had scaffolding for several years. (Photograph by author.)

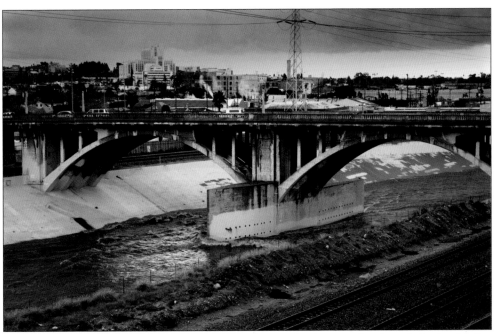

Here is Spring Street after a storm, streaked with rain. Looking at the drain holes in the fin, one can see that for a few minutes, the water was at least as deep as the top drain hole, which is far higher than people can reach. In the background are the Brewery Artist Colony and Los Angeles County–University of Southern California Medical Center, the largest hospital west of the Mississippi. (Photograph by author.)

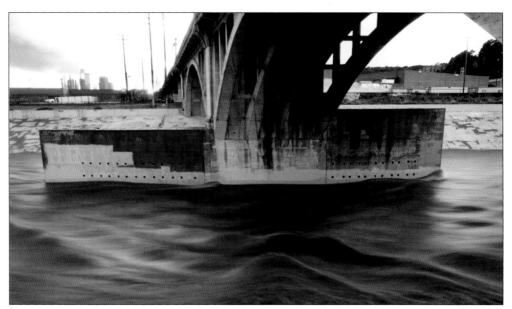

This view to the west, after a storm, is of the receding water level. This was shot at the same location of the rebar installation in the photograph at the bottom of page 32. (Photograph by author.)

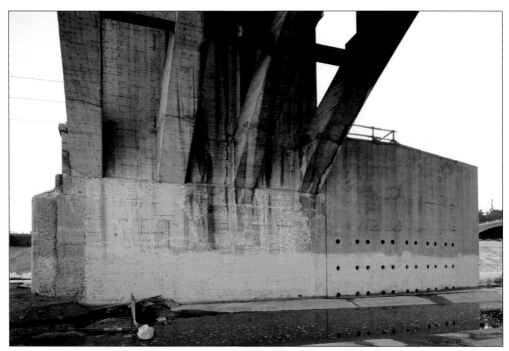

Here is the center pylon of the Spring Street bridge with the downstream fin removed at left. Between the ribs, one can see decades of rain tracks and seepage. The top row of limber holes on the right are higher than a man can reach. (Photograph by author.)

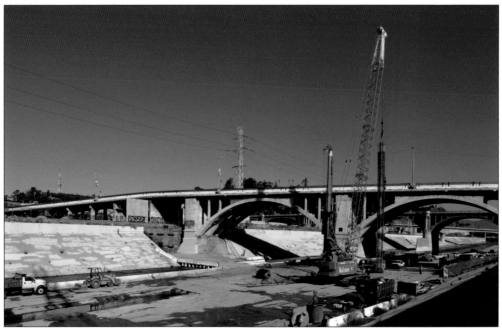

In this intriguing image, work on Spring Street is progressing in the summer of 2014. The crane is lifting a rebar "cage," which is about 100 feet/30 meters long, to drop into a hole in front of the pier. Several minutes later, this cage will disappear completely within the riverbed. On the left is the usually hidden underground foundation of the western arch. (Photograph by author.)

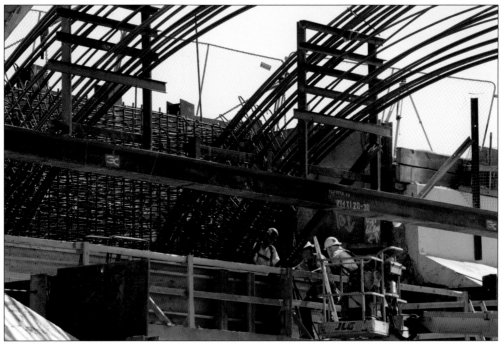

This view of the east bank at Spring Street shows the massive rebar used in the 21st century, held in large jigs to maintain the delicate curve. By 2015, this was already under new concrete. (Photograph by author.)

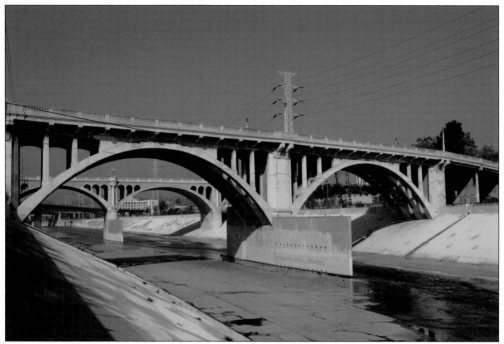

This beauty shot from 2012 shows Spring Street as it appeared before being tagged with spray paint. Compare this shot to the next one taken in 2014. (Photograph by author.)

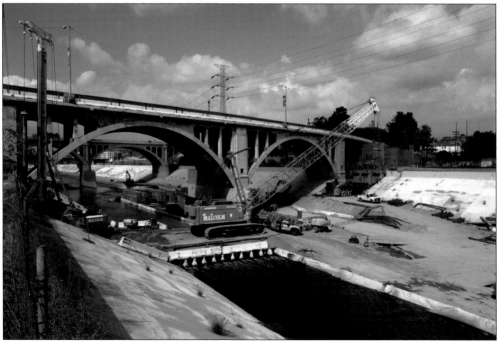

This photograph was taken in the identical location as the previous one; however, it was taken in 2014. The earlier photograph of the rebar was shot where the forklift is waiting under the huge crane. The mighty fin is gone, and the low-flow channel is moved to the far west bank. (Photograph by author.)

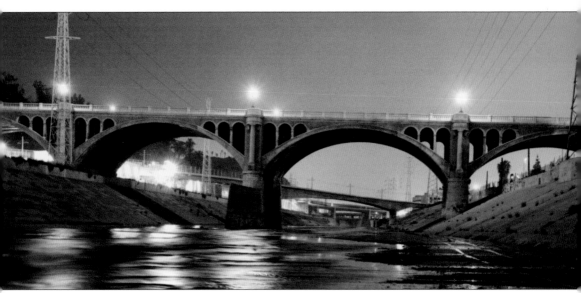

This beautiful night photograph of the Broadway bridge reveals its sinuous graceful lines. To the north are freeway bridges and a railroad bridge. This bridge was refurbished and brought up to seismic standards between 1992 and 1994 and won an award for preservation excellence. It is the most detailed of all the bridges over the river. It has spans up to 118 feet/36 meters wide. The huge central pylon has a large fin that may have been added several years after construction; there are photographs extant showing this on other bridges as well. The fins may have been added for appearance's sake; the pylons function well without them. The fins, however, make quite a statement! (Photograph by author.)

Four

NORTH MAIN AND MACY STREETS VIADUCTS

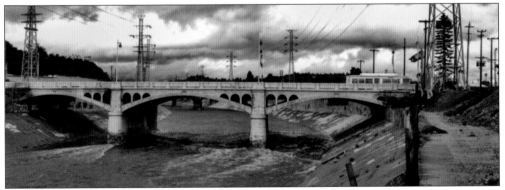

This 2008 photograph shows how diminutive the Main Street bridge is in relation to the other bridges. Compare the shape of the open spandrels with the rebuilt ones on page 40. (Photograph by author.)

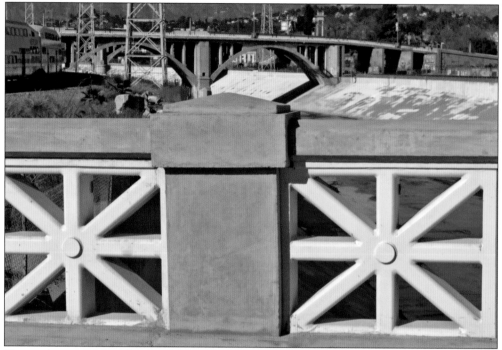

Here is the new, restored railing being installed early in 2015. It is a replica of the original but is much stronger to deal with heavier, faster cars. Unfortunately, the North Main Street bridge has its share of car accidents. At about the spot the photograph was taken, four young people died in a car accident in 2002. During most of the 20th century, the railing was replaced by a much sturdier massive concrete wall. (Photograph by author.)

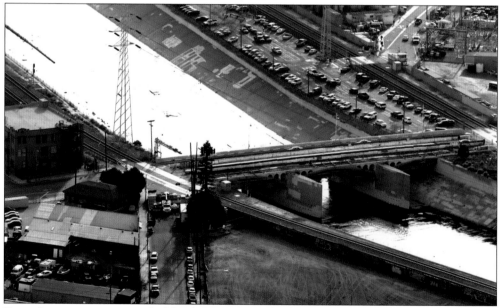

From the air, one can see why North Main Street bridge is the least loved bridge. It does not have a grade separation for train traffic! This is why it is the shortest bridge at about 300 feet/100 meters long. (Photograph by author.)

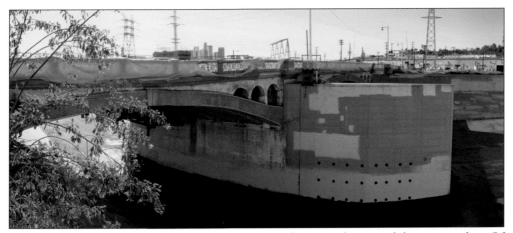

This cropped picture from a much larger panorama shows a side view of the massive fins. Of interest is the gray paint on the bottom to cover the incessant graffiti. The gray band covers about as high as teenagers can reach, 7 feet or 3.2 meters. In the storm photographs on pages 38 and 39, one can see the top row of limber holes is touching the water, which is 12 feet/4 meters deep! (Photograph by author.)

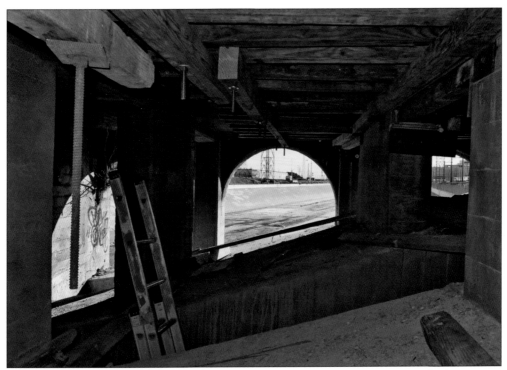

This view from inside one of the arches shows the falsework supporting the new roadbed. It appears that most of the bridge is being replaced. There is a lot of unused space inside the bridge. It has been a home for the homeless for decades. (Photograph by author.)

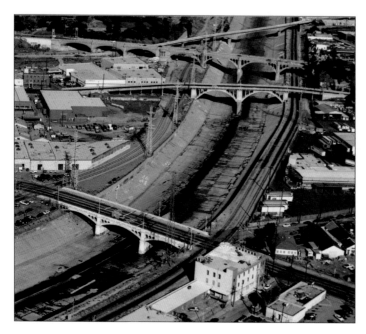

This interesting aerial photograph shows, from bottom to top, North Main Street, Spring Street, and Broadway bridges to the north. From the previous photograph, one can see just how much earth was excavated to pave the river. Also note how North Main Street does not clear the rail crossing (grade separation), while Broadway clears five tracks. The fins on North Main Street bridge are upstream, while the others are downstream. (Courtesy of the Library of Congress.)

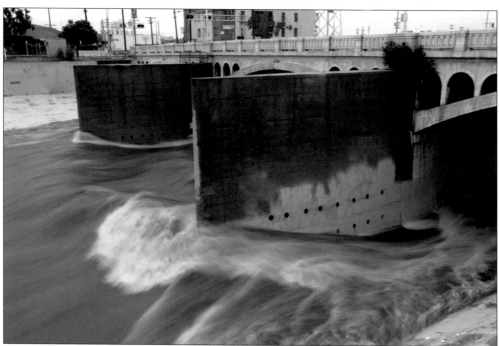

This view is from upstream, and one can see the giant fins cutting the flood waters. The crests are over 10 feet/3 meters high. Most Angelenos are not familiar with how much water the river moves during a storm. At this depth, it sometimes kills those unfortunate enough to wind up in it. Every year, people are rescued from the storm waters, and often they are rescued at this bridge as it is the lowest of the collection. (Photograph by author.)

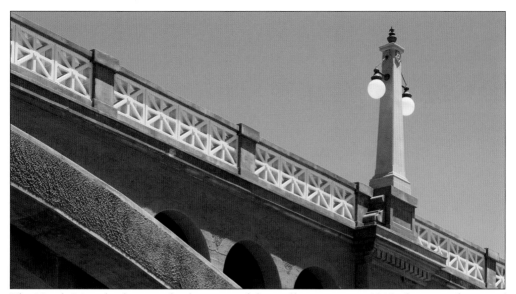

The North Main bridge completely reopened for traffic in summer 2015 after several years of seismic refits. Of interest is the complete restoration of the bridge to better-than-new condition. The original streetlights returned and replaced the ubiquitous, unloved cobra-style lights, and the original railing design returned, although many times thicker. This most comprehensive refit means that every part of the bridge in this image is brand new! (Photograph by author.)

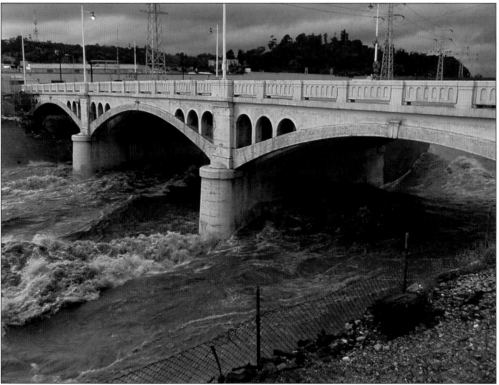

This view from 2001 shows just how much dirt the river waters sweep up. Under the center of the bridge, the wave crest is about 12 feet/4 meters high. (Photograph by author.)

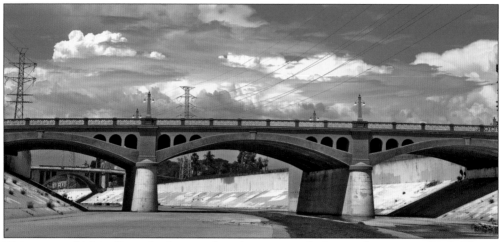

This image of Main Street bridge was shot the same week that work was completed. This is the best the bridge will ever look! This structure alone in the set of downtown bridges is not a viaduct but purely a bridge. After this refit, the spandrels look subtly different; has the arch geometry changed? Note the dark grey color above the two pylons; this is all new construction. Originally constructed to carry light rail down the center of the decking, perhaps later this will also be revived. (Photograph by author.)

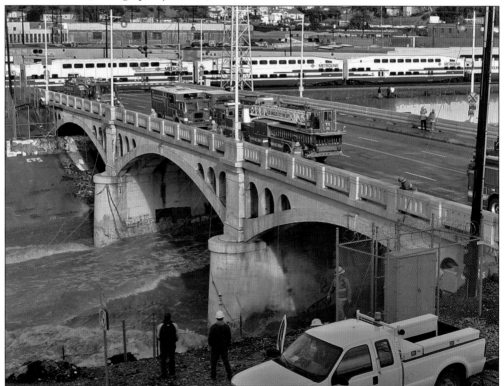

This 2005 image shows the Los Angeles Fire Department (LAFD) conducting river rescues during a flood. Since North Main Street bridge is the lowest bridge, without a grade separation, the LAFD holds drills and, some days, actually perform rescues from this bridge. They have used floats, nets, divers, and, one time, a Jet Ski. (Photograph by author.)

Sunset Boulevard is a famous street almost 47 miles/76 kilometers long. However, as it crosses the Los Angeles River, it name changes to Macy Street. This road was also known as El Camino Real by the Spanish priests who began a number of missions in California in the late 1700s. This bridge was designed in a Spanish style to reflect this, as seen in the ornate pylons and streetlights. (Photograph by author.)

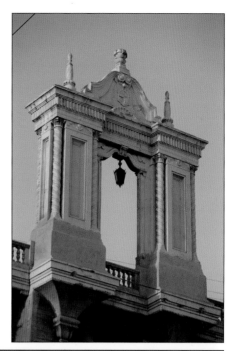

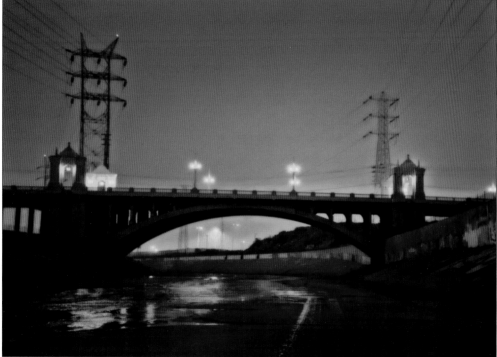

Here is a night view of the Macy Street bridge from inside the river. In 1870, the first semipermanent bridge crossed the Los Angeles River here at Macy Street. All of the ornamentation is on the street level, with nothing to see from inside the river, unlike Broadway bridge. Most of the bridge crossings today have had several bridges predating them; the older bridges were either destroyed by floods or rebuilt to go over the railroad tracks. (Photograph by author.)

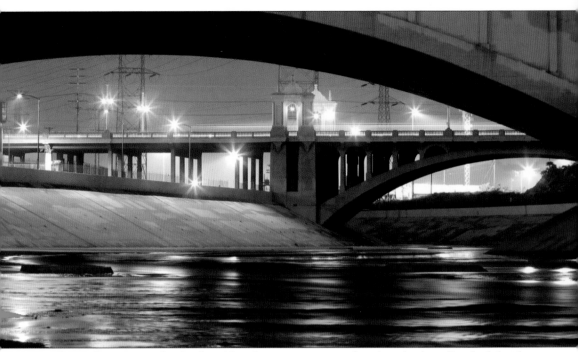

This night view reveals why the railroads were so interested in these bridges. On the left side are a number of "bents," or ribs, in the bridge structure that clear the railroad tracks, leaving plenty of room for trains. (Photograph by author.)

Macy Street is easily the most ornate bridge in this set. Compare this fancy pylon to the pylons on the First Street bridge. This pylon looks relatively intact as graffiti taggers cannot reach high enough to paint the columns. (Photograph by author.)

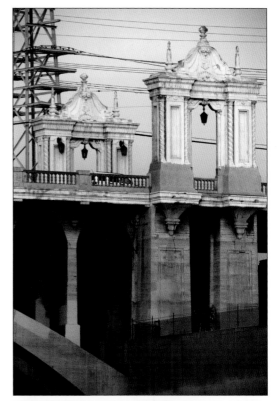

Here is an oblique aerial shot of Macy Street. The fancy decorations can be seen from far away. Hidden from this angle, Aliso Street bridge now supports part of the 101 Freeway. (Photograph by author.)

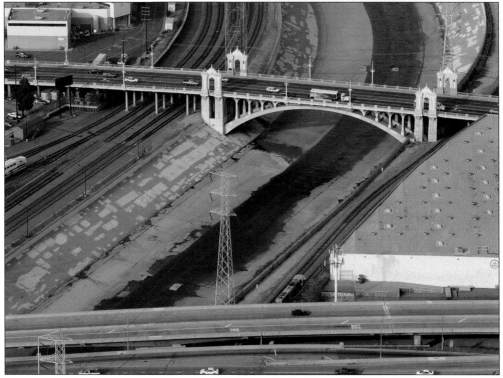

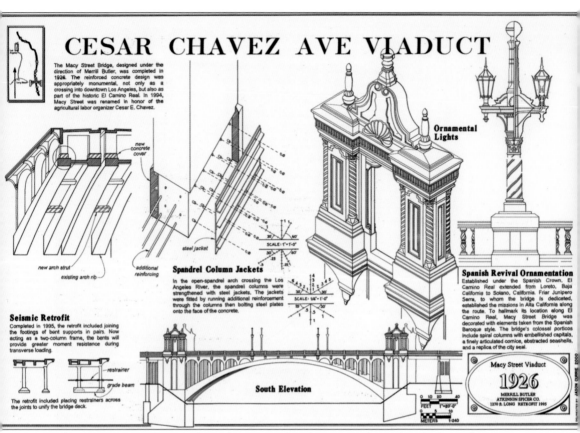

CESAR CHAVEZ AVE VIADUCT

The Macy Street Bridge, designed under the direction of Merrill Butler, was completed in 1926. The reinforced concrete design was appropriately monumental, not only as a crossing into downtown Los Angeles, but also as part of the historic El Camino Real. In 1994, Macy Street was renamed in honor of the agricultural labor organizer Cesar E. Chavez.

new concrete cover

steel jacket

SCALE: 1"=1'-0"

new arch strut

existing arch rib

additional reinforcing

Spandrel Column Jackets

In the open-spandrel arch crossing the Los Angeles River, the spandrel columns were strengthened with steel jackets. The jackets were fitted by running additional reinforcement through the columns then bolting steel plates onto the face of the concrete.

SCALE: 1/4"=1'-0"

Ornamental Lights

Spanish Revival Ornamentation

Established under the Spanish Crown, El Camino Real extended from Loreto, Baja California to Solano, California. Friar Junipero Serra, to whom the bridge is dedicated, established the missions in Alta California along the route. To hallmark its location along El Camino Real, Macy Street Bridge was decorated with elements taken from the Spanish Baroque style. The bridge's colossal porticos include spiral columns with embellished capitals, a finely articulated cornice, abstracted seashells, and a replica of the city seal.

Seismic Retrofit

Completed in 1995, the retrofit included joining the footings of bent supports in pairs. Now acting as a two-column frame, the bents will provide greater moment resistance during transverse loading.

restrainer

grade beam

The retrofit included placing restrainers across the joints to unify the bridge deck.

South Elevation

0 10 20 40
FEET 1"=20'-0"
0 5 10
METERS 1:240

Macy Street Viaduct

1926

MERRILL BUTLER
ATKINSON SPICER CO.
1270 B. LONG RETROFIT 1995

This axonometric drawing from the National Park Service shows details about the Macy Street Viaduct. (Delineated by Jason Currie, Historic American Engineering Record [HAER], National Park Service.)

Five

FIRST AND FOURTH STREETS BRIDGES

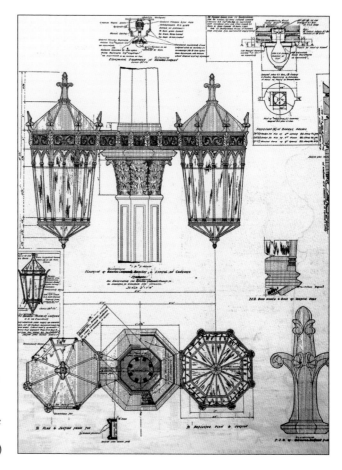

Imagine going from a wooden bridge to a solid concrete one, with streetlamps like these! Los Angeles was certainly dressed to impress. These streetlight drawings are from the original plans of the Fourth Street bridge, which specified opalescent glass. However, in recent years, photographs of the glass show the glass to be more opaque. (Photograph by author.)

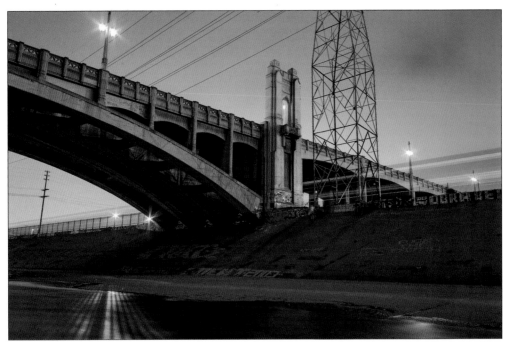

Fourth Street bridge has always been a class act. It is known for Gothic details and is one of the most striking of all the bridges in this set. This predawn photograph shows details of the eastern bank and a time-lapse trail of an Amtrak passenger train. One of the impressive belvederes looks over the train passing below.

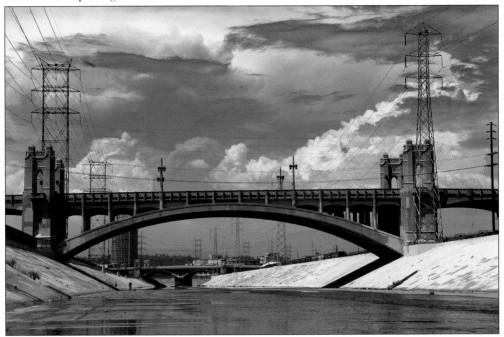

This gorgeous view to the north of Fourth Street bridge has stunning storm clouds in July 2015. As always, if inside the river, keep an eye on the weather. In the distance, First Street bridge also basks in the afternoon sun.

Note the railings of all the bridges—no two are the same. Fourth Street has a trefoil design and the original streetlights can be found; however, not all are in one piece. Fourth Street bridge cost over $2.25 million in 1931 money and was declared a monument by the city. There are four belvederes, or balconies, with built-in seats overlooking the river. (Photograph by author.)

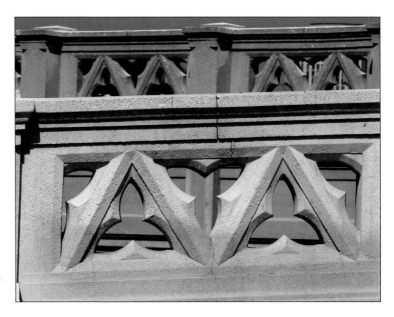

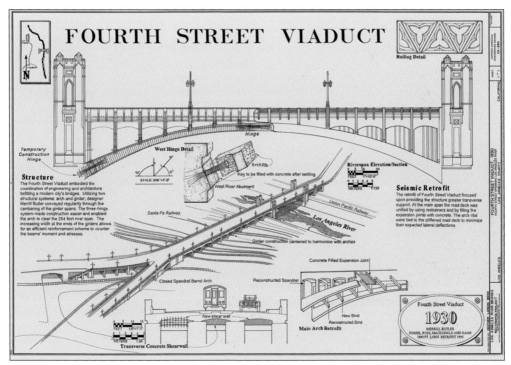

This beautiful cutaway drawing illustrates the unseen interior of the Fourth Street Viaduct. It shows the unique three-hinge construction and some of the seismic refitting done in 1995. Of interest at bottom are period vehicles showing scale. The span over the river measures 254 feet/77 meters. (Delineated by Heather Larson, HAER, National Park Service.)

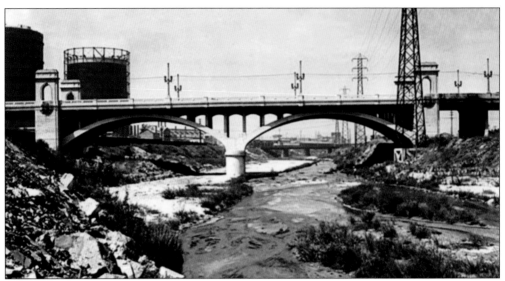

This image of First Street bridge as constructed in 1929 holds a lot of interest. The railroad bridge that was replaced by the 101 Freeway can be seen upstream. In the near distance is seen the natural but still confined riverbed, filled with boulders (and trash), soon to be paved. On First Street bridge, the original construction with the open spandrels can be seen, and the debris fins have not been added yet. Smoke from trains stain the far-right bents. The large circular petroleum tanks were removed by the 1980s. (Courtesy of the City of Los Angeles Bureau of Engineering.)

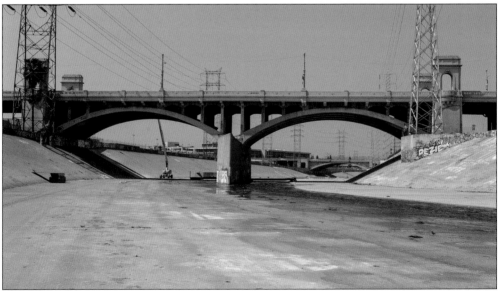

This is an almost identical view after the passage of 80 years. The streetlights have finally been restored to the original design, though extra ones are added in the pylons' arches. The viaduct has been widened, train tracks reinstalled, and the debris nose has been installed, removed, and then replaced. Seagulls in the foreground echo the helicopters on the roof of Piper Tech. The riverbed has been deepened and paved. (Photograph by author.)

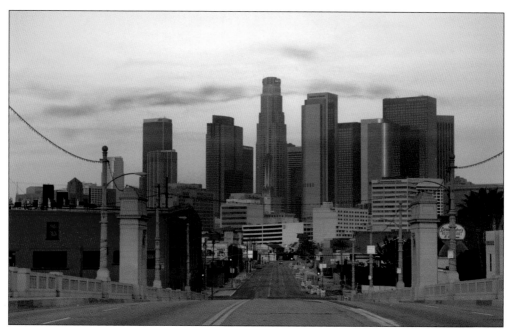

This 2006 photograph of First Street bridge was taken looking west into downtown, before the bridge widening project. The brick building at left stands at 900 East First Street, one of the first live/work lofts created in the 1980s. (Photograph by author.)

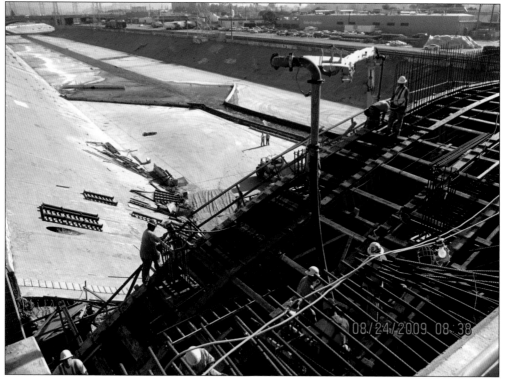

Workers are preparing to pour the arch extension of First Street bridge in 2009; note how much rebar is going in. (Photograph by author.)

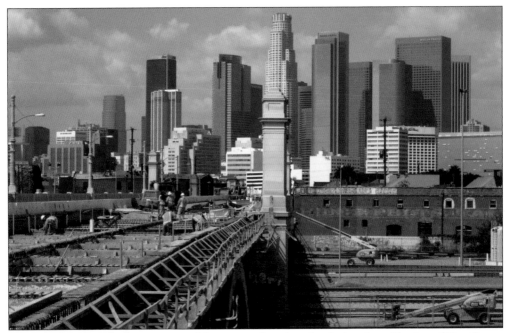

This gorgeous view looks west toward downtown Los Angeles during the widening of First Street bridge. Here, one can see the roadbed being reinforced as well as widened to 26 feet/8 meters before the removal of the pylons, each weighing an estimated 165,000 pounds/75,000 kilograms. Construction took around four years at a cost of about $100 million. (Photograph by author.)

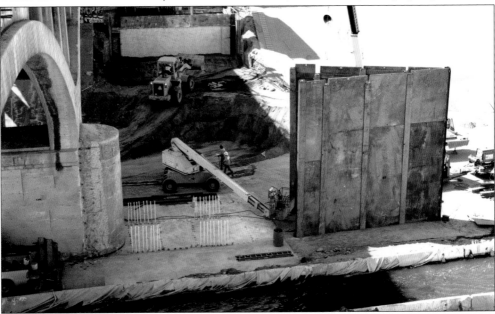

This fascinating photograph from 2009 shows the installation of a temporary steel debris nose on First Street bridge. The contractors were not allowed to work in the river from October to April each year due to storms. Later, the pylon will be replaced by a permanent debris nose. At left, one can see the original blunt-rounded pier, which has been inside the debris nose for decades. At top, one can see the excavation for the widening supports. (Photograph by author.)

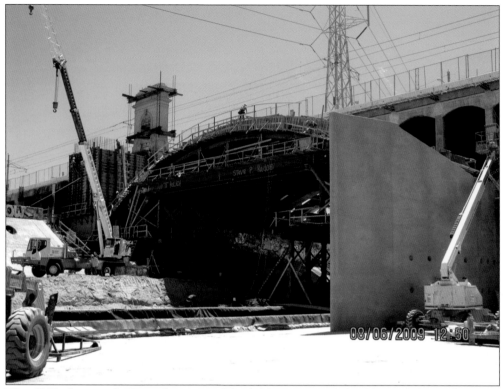

This 2009 photograph shows the new and final debris nose and the falsework that will support the new roadbed. Above, one can see the arched pylon being readied for removal. Its new location will be about 26 feet/9 meters to the north. (Photograph by author.)

Lots of sand fills the hollow fins, and high-water marks from various storms and floods mark the walls. (Photograph by author.)

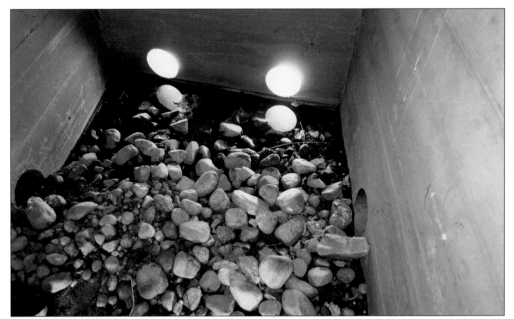

In one pylon, there is a collection of rocks. These have been accumulating for about a century. (Photograph by author.)

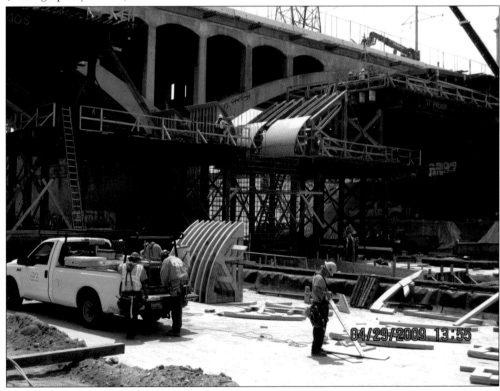

This 2009 photograph of First Street bridge reveals just how much woodwork goes into a concrete bridge. Here, the wooden forms are being handmade to shape the concrete identical to the original plans but much stronger. (Photograph by author.)

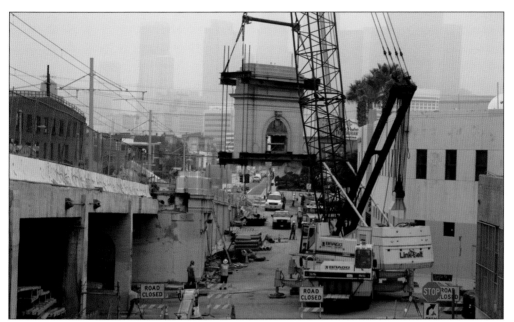

Here, the first pylon is removed to widen First Street bridge. After getting ready for hours, the actual lift took less than five minutes. Note the steel cage emplaced around the pylon, working to keep it in one piece. (Photograph by author.)

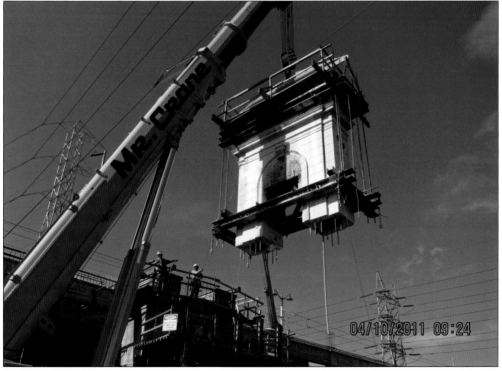

This photograph shows the replacement of one of First Street bridge's original pylons, which was done at great expense and difficulty. Note the high-voltage lines directly above the crane. The pylon was cast in place in 1929 and never was intended to be removable. (Photograph by author.)

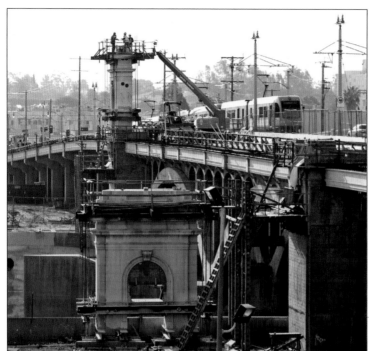

This busy 2011 photograph of First Street bridge shows one pylon that has been replaced and another in the foreground with a cage of steel around it to keep it in one piece. Even before the bridge was finished, trains were using it every few minutes. Note the workmen atop the pylon. (Photograph by author.)

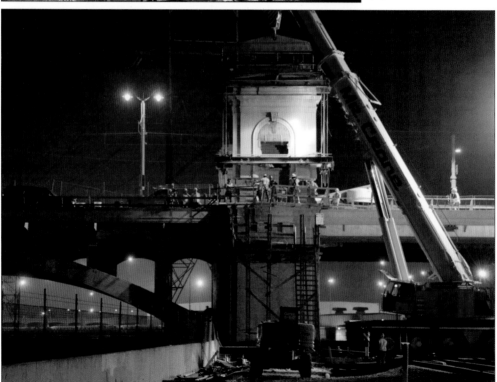

This intriguing photograph of First Street bridge shows a very hazardous night operation to replace one of the pylons. Just above the crane, out of frame, are the 235,000-volt lines that power downtown Los Angeles. A mistake here could kill people. (Photograph by author.)

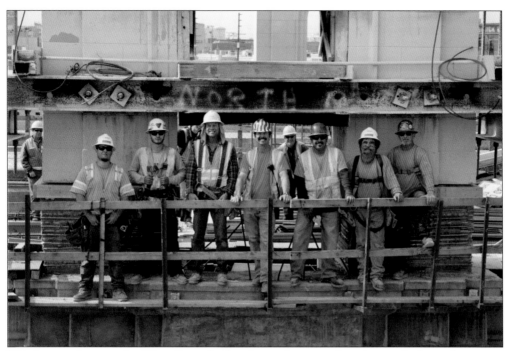

This happy photograph of First Street bridge shows the crew after placing the last pylon on its new pediment in 2011. (Photograph by author.)

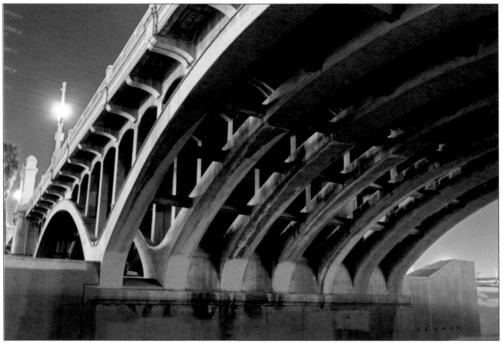

This beautiful shot shows the graceful concrete ribs underneath First Street Viaduct. Two ribs were added on the right, which are outwardly identical to the originals on the left. The debris nose on the far right is also identical, although moved upstream. (Photograph by author.)

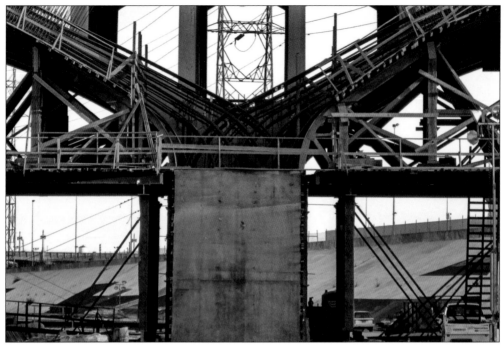

This view of the rebar and wooden forms behind the debris nose was taken looking to the south. One can see the rebar is thick and massive, and the back of the pylon is solid concrete. (Photograph by author.)

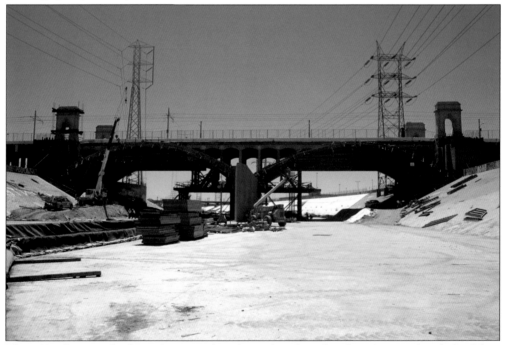

This 2009 photograph of First Street Viaduct shows that the pylons have been replaced, the debris nose is finished, and now the arches are getting the roadbed forms installed. On the far left pylon, the metal braces are still fitted from the lift. (Photograph by author.)

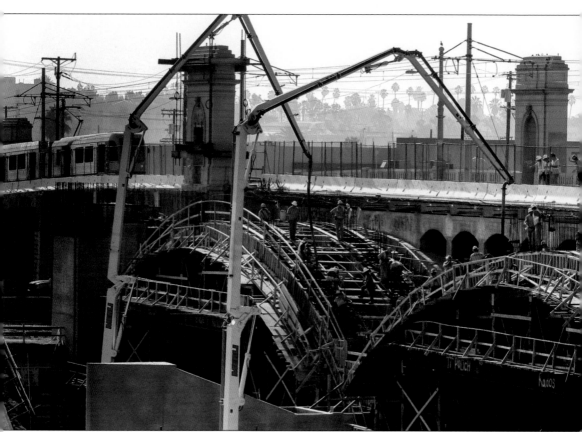

This image shows one of the intricate and costly concrete pourings during the First Street Viaduct widening project. During this time, the bridge was open for use, and one of the new electric trains is visible on the left. On the far right, one of the massive bulwarks that will support the pylons is almost completed. Below center, the new debris nose awaits its roof. (Photograph by author.)

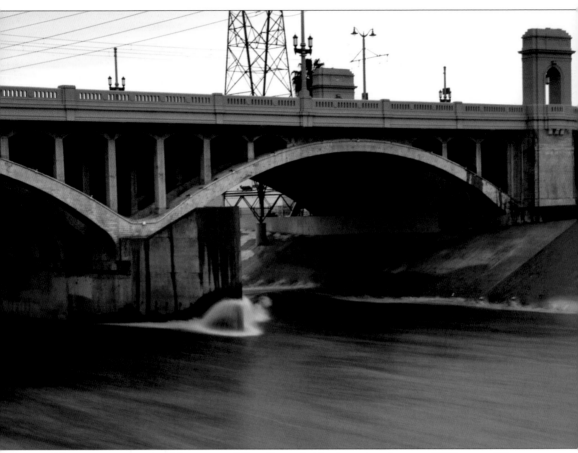

Here, one can see the debris nose of First Street bridge in action during a 2012 storm. The water depth is about 4 feet/1.5 meters and is more than strong enough to carry a car downstream. The bow wave is about 11 feet/3.5 meters high and has fallen 3 feet/1 meter in the past few minutes. (Photograph by author.)

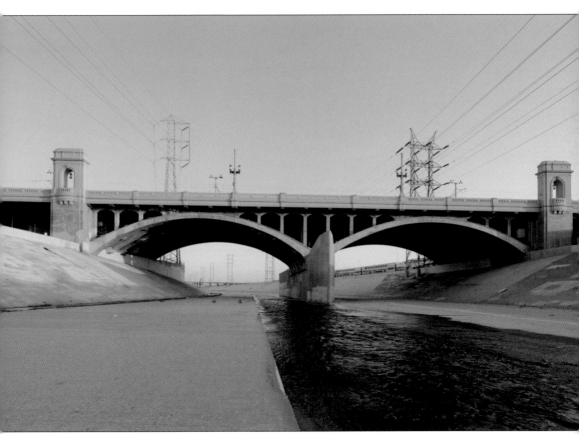

This sunset photograph shows the widened First Street Viaduct with the graffiti painted out not long after completion. At this point, the bridge is better than new. (Photograph by author.)

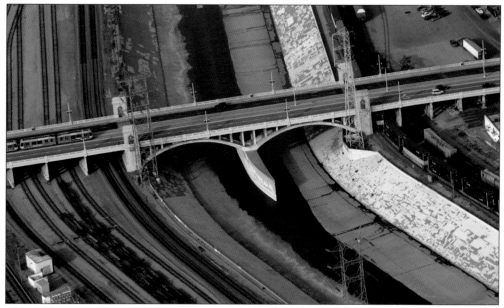

This 2014 aerial photograph shows that First Street, like many of the other bridges, is not symmetrical. The fin curves to follow the water flow. One of the new light rail trains is on the left, bringing to mind the renaissance of downtown Los Angeles! (Photograph by author.)

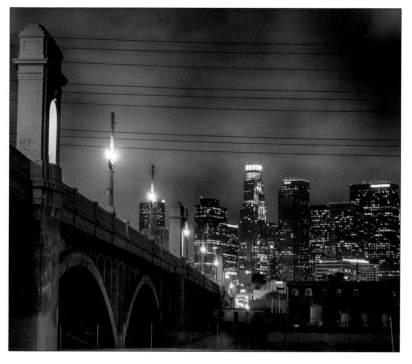

This impressive night view looks west into downtown and Little Tokyo. When First Street was built, there was no view to compare to this. (Photograph by author.)

Six

SIXTH AND SEVENTH STREETS VIADUCTS

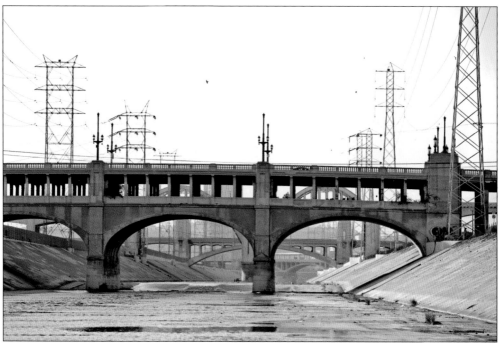

This modern view of Seventh Street reveals the original bridge deck and the newer one built above it. In the background, one can see Sixth, Fourth, and First Street bridges receding to the north. (Photograph by author.)

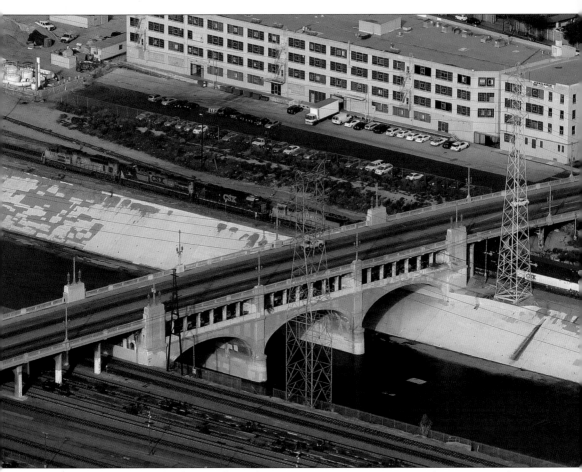

This 2014 view from the sky reveals just how important it was to create grade separations for train traffic. Only the original bridge deck can be clearly seen below the current deck. Raising the bridge made it much longer yet trains were no longer delayed since the crossings were eliminated. The large green building, used for many years for band rehearsals, is now being turned into lofts like the rest of the Arts District. (Photograph by author.)

This image, looking north, shows the style of streetlights from 100 years ago. The lights and the balustrade are not original. Much was removed in a 1970 refit but was restored in a 1998 seismic refit. In the background is the magnificent vista of the Sixth Street bridge that drew the restaurateurs' interest. (Photograph by author.)

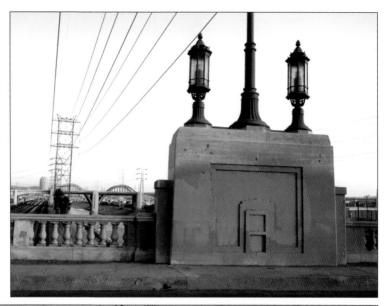

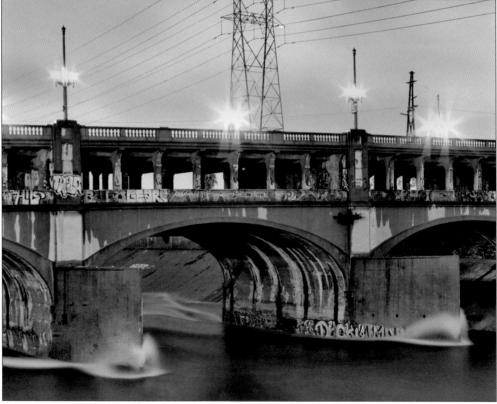

This nighttime exposure shows how the fins cut the storm waters; the water pictured here is about four feet/three meters deep. Perhaps, the ship-like debris noses were fitted just for looks; Broadway, for example, is lacking such a nose. The graffiti comes and goes over the years, and at the time of this writing, it is less under control. There has been talk about building a restaurant on top of the old Seventh Street bridge, under the more recent road deck! (Photograph by author.)

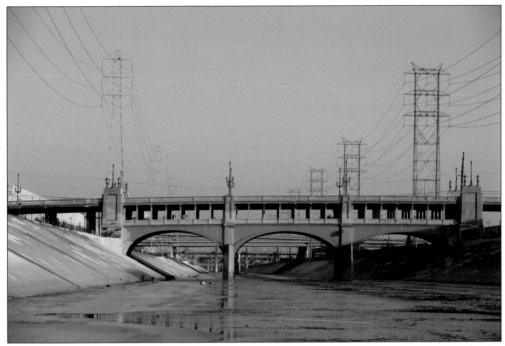

This view of Seventh Street clearly shows the old, shorter bridge surmounted by the 1927 bridge that clears the train tracks. On the left, laundry is hung up to dry inside the bridge. (Photograph by author.)

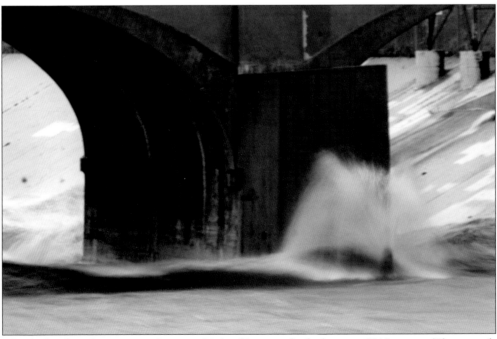

This lucky shot shows water shooting 20 feet/7 meters high during a 2010 storm. (Photograph by author.)

This detail photograph shows the streetlights atop Seventh Street. They rest upon columns built in the 1927 expansion that exactly match the original columns from 1910, which would now be over a century old. These lights can be seen in movies, the most recent being the 2011 science fiction film *In Time*. (Photograph by author.)

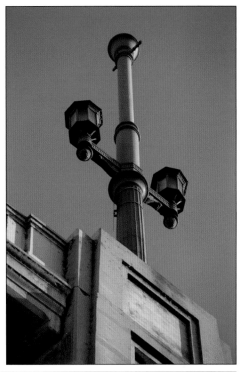

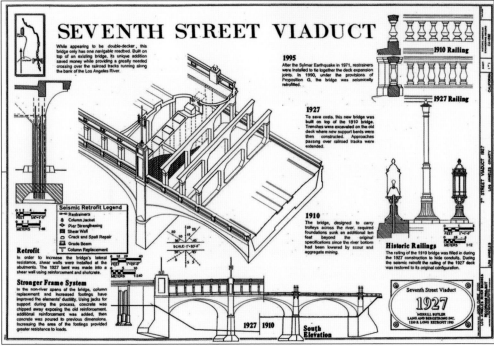

This intriguing axonometric drawing clearly shows the old and new viaducts, one atop the other. Details such as streetlights and balustrades are also visible. As designed in 1910, the original viaduct had a surprising amount of concrete underground and out of view. (Delineated by Jason Currie, HAER, National Park Service.)

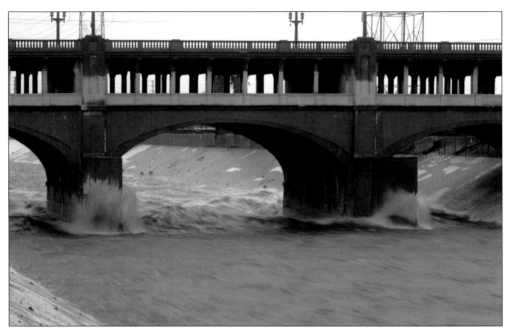

This rare view of Seventh Street during a storm shows floodwaters at about 6 feet/2 meters deep and bow waves hitting over 12 feet/4 meters in height. Although the city owns the bridge in its entirety, it paid for only 18 percent of cost. The rest was carried by three railroads that had a vested interest in maintaining their right-of-way. (Photograph by author.)

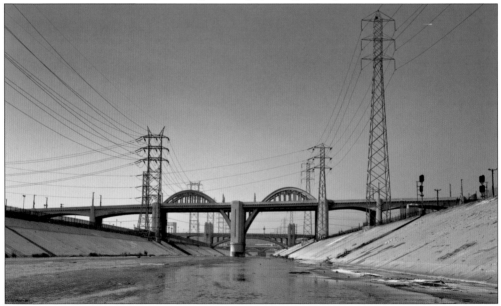

Sixth Street bridge is the most famous, by far, of this collection. It has appeared in so many movies and videos that no one really knows how many. In 2011 alone, there were at least 100 permitted productions on or under the viaduct. Sixth Street bridge is what most people think of when they consider the downtown bridges. Unfortunately, this bridge's time is running short. It is due for demolition in 2015 and will be replaced by 2018. Will the new replacement bridge be as popular for filming? Time will tell. (Photograph by author.)

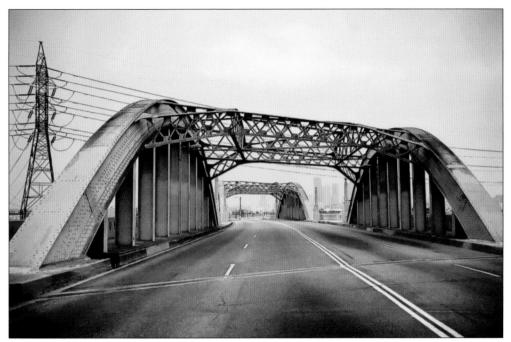

This is the Sixth Street bridge, viewed by car. This is what Angelenos see when crossing the bridge. Beyond it is one of the most striking views of downtown Los Angeles, looking toward the west. (Photograph by author.)

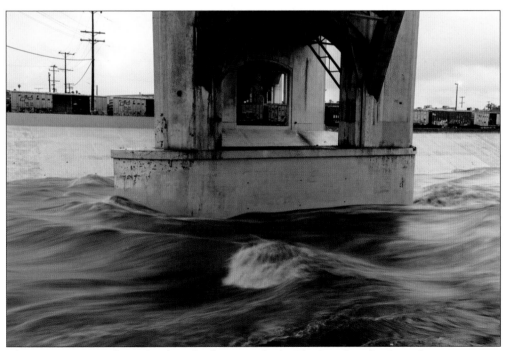

This 2010 storm wash is why these bridges were built. The Los Angeles River has eaten many other bridges in the past. The water here is deep enough to pick up a car and send it 24 miles downstream to Long Beach. (Photograph by author.)

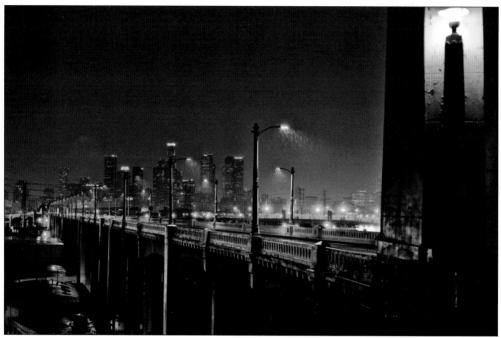

This is the spectacular view of a rainy downtown Los Angeles. In the foreground, one can see the Sixth Street Viaduct as a gateway to the city. (Photograph by author.)

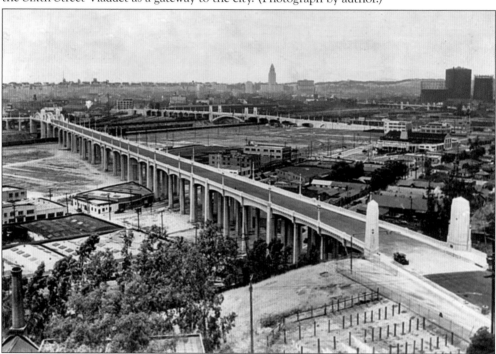

This photograph was made shortly after the Sixth Street bridge opened in 1932. It was taken from almost the same spot as the preceding photograph but higher. The far right shows the entry pylons to the bridge on the eastern approach, and one can see from the two photographs how much Los Angeles has grown. (Courtesy of the City of Los Angeles Bureau of Engineering.)

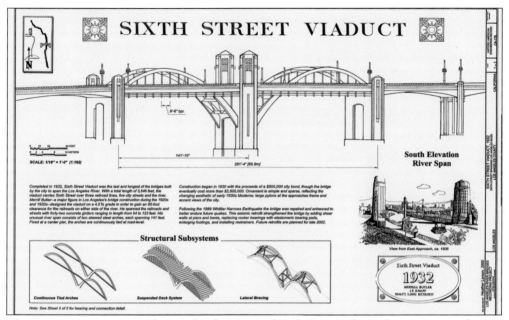

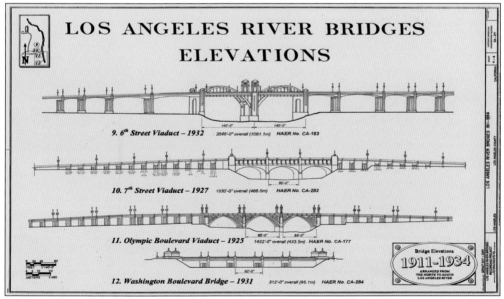

This gorgeous axonometric drawing by the National Park Service shows the structure and, more importantly, the towers that were once on the bridge. There were six such towers, with two of them being the highest part of the bridge in the center of the two arches. Within a short period of years, the towers had to be removed due to problems with the concrete. Whether or not the looks of the bridge were improved are moot. Everyone today is used to the bridge as it appears sans towers. Note that this drawing shows only the central portion of the viaduct. (Delineated by Heather Larson, HAER, National Park Service.)

Here is another drawing by the National Park Service. One can see that Sixth Street is the longest of all the downtown Los Angeles bridges, and it was also the longest concrete bridge in the state of California for a period. It is 3,500 feet/1.06 kilometers in length, and the arches soar 280 feet/86 meters across the river. (Delineated by Grant Day, HAER, National Park Service.)

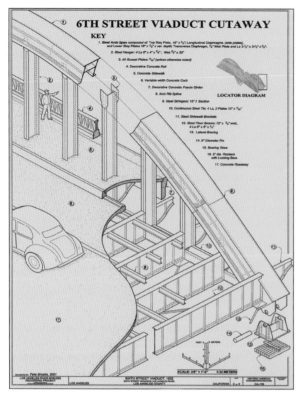

This view shows the structure of the massive arches. The metal in the bridge is in fine shape, and there is some talk of preserving some of the arches in a park underneath the replacement viaduct. (Delineated by Pete Brooks, HAER, National Park Service.)

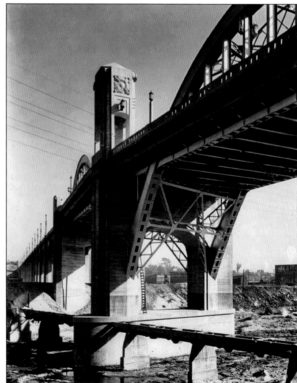

This eastward 1931 view shows the long-gone towers between the arches and the dirt riverbed. Also, at bottom is the curious pipeline, set in concrete but now entirely gone. (Courtesy of the City of Los Angeles Bureau of Engineering.)

Here is a detail photograph of the arches as they go through the bridge; contrast this with the previous drawing. Atop the girders are the ever-present pigeons. Occasionally the bridge has been closed for benefits and parties, which are always held under the arches. (Photograph by author.)

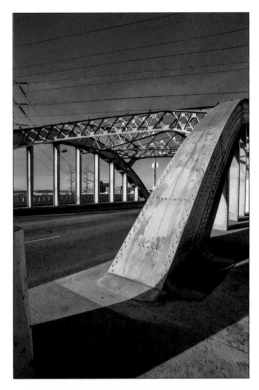

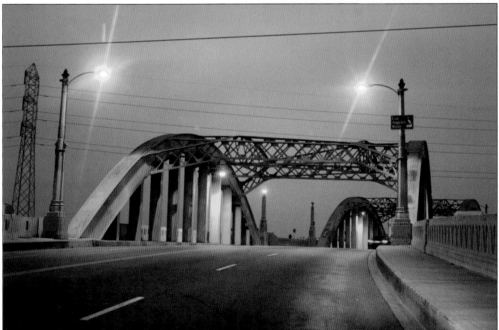

Here is the driver's view going east over the Sixth Street bridge. One can see the bridge curves abruptly right at the arches. This has been a problem area since the bridge opened; there have been a number of accidents and even fatalities at this juncture. The new viaduct will solve this "kink," as the engineers and others call it. (Photograph by author.)

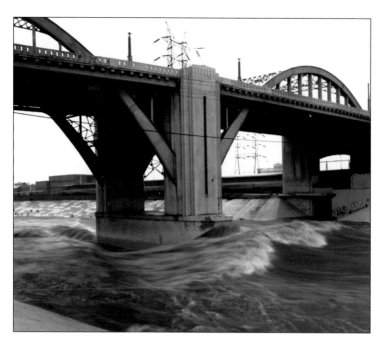

Here is a view of Sixth Street bridge dealing with a rainstorm. In the background, an Amtrak train accelerates away from Union Station. The storm water at the pier is peaking about 20 feet/6 meters high. The sound of the water is like a rushing freight train. The water makes standing waves at the front of the pier, tossing and churning, and the foam stays right there as if the river were eating itself. (Photograph by author.)

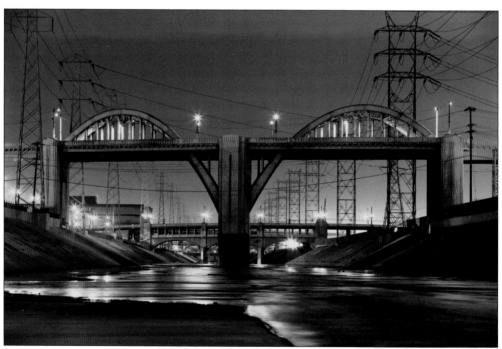

Here is what the river looks like most of the time—quiescent, burbling to itself as it sleeps. In the background, the Seventh Street bridge can be seen, and a glimpse past that is the Olympic Boulevard bridge. Sixth Street was the last of the bridges that Merrill Butler presided over and the largest. Will its replacement look as striking? (Photograph by author.)

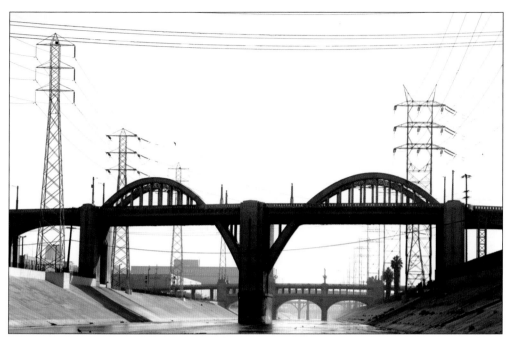

Generations of children have grown up playing in or around the Los Angeles River, and this is what their memories of Sixth Street bridge look like. Readers may remember this bridge from the movie *Grease* where the car races were held. Down in the river, traffic sounds die out and are replaced by the sound of birds. (Photograph by author.)

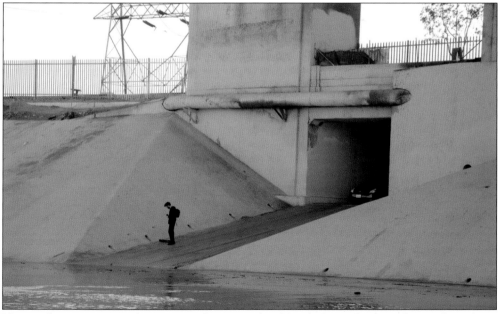

Here is the entrance to the river on the west side of Sixth Street bridge. The pipeline above the entrance predates the bridge itself. Older readers may recognize this tunnel from the movie *Them* (1954). Pictured is a photographer looking at his gear. Also note the car, which is parked in the worst possible spot, blocking all other vehicles from entering or exiting the river for miles. (Photograph by author.)

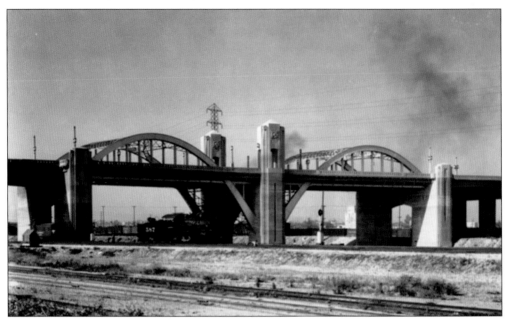

This view of Sixth Street bridge shows the original towers and a bit of rail traffic underneath. The rail yards of the 1930s have been substantially upgraded as far as security; see the following photograph. (Courtesy of the City of Los Angeles Bureau of Engineering.)

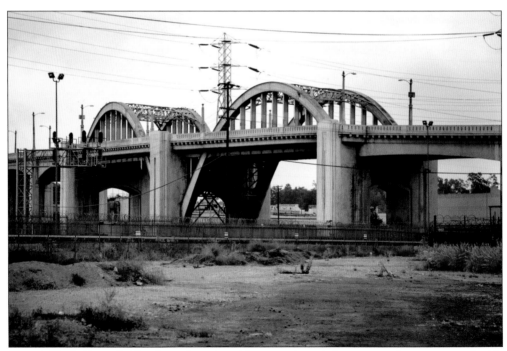

Here is Sixth Street bridge from the other side; now there is fence upon fence, crowned with barbed wire, and tall light poles everywhere. A dramatic difference can be seen atop the bridge now that the six towers are gone. (Photograph by author.)

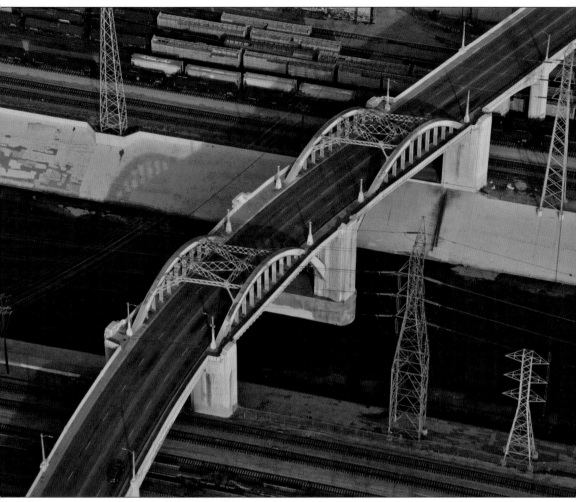

Here is an aerial photograph of Sixth Street bridge; the interesting latticework between the arches is clearly visible. It does not appear to match the arches but does show up in the earliest photographs. Perhaps it is for seismic reinforcement. A forest of electric power towers now surrounds this bridge and the others. It is hard to envision the viaducts without all the towers around them. (Photograph by author.)

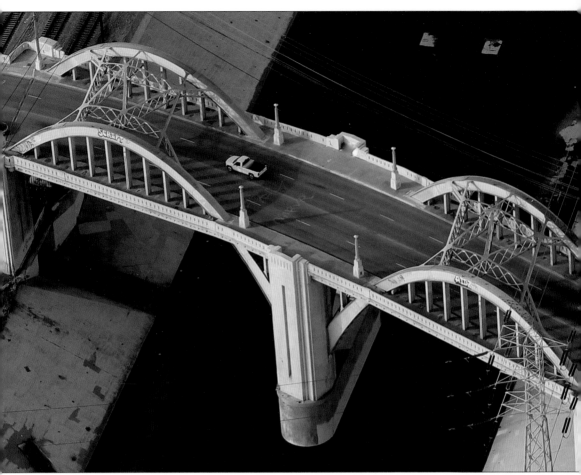

A close-up of the arches reveals that the metal latticework is not symmetrical. The diagonal braces in the center of the latticework are the key. On top of the center pier are the outlines of the long-gone towers. (Photograph by author.)

This view from underneath Sixth Street bridge reveals more of the delicate traceries of steel and an incredible multitude of rivets, which are now long out of style. The inner braces are identical to the braces on the arches above. (Photograph by author.)

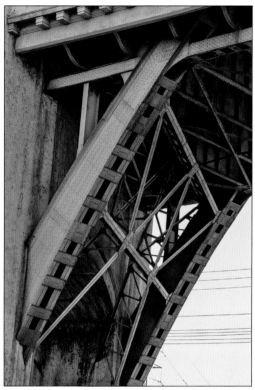

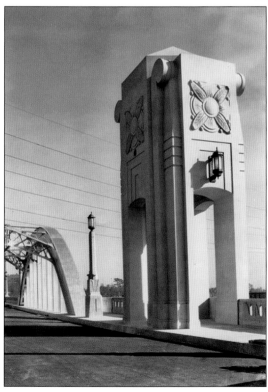

This photograph was taken right after Sixth Street bridge was completed in 1932. (Author's collection.)

77

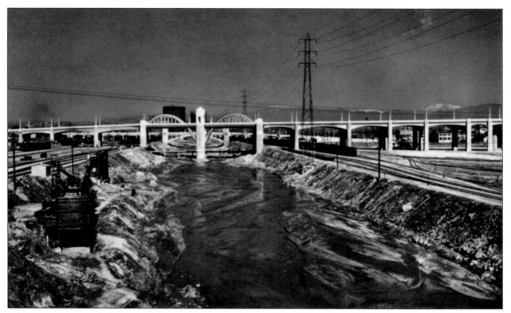

This is an expanded view of the viaduct crossing railroad tracks and the Los Angeles River. Of interest are the decorative towers, the unpaved river, oil tanks where the 101 Freeway is now, and only one set of power towers. (Author's collection.)

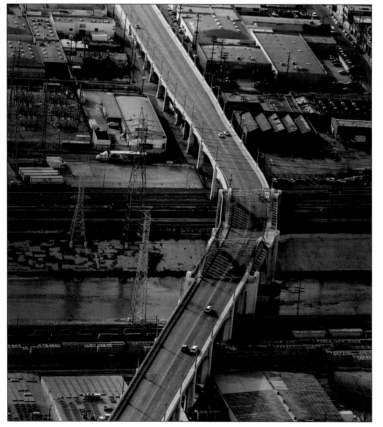

This curve, or "kink," in the roadway is deadly and is another reason as to why the bridge must be replaced. What a driver might take at a slow speed without notice becomes impassable at high speed. At freeway speeds, a car will either go up on the sidewalk, or spin into oncoming traffic. A number of people have died because of the kink in the road. (Photograph by author.)

Here is a photograph of the decay that is the death knell for Sixth Street. It is called ASR, or alkali–silica reaction, and in a nutshell, the concrete is slowly disintegrating and cannot be repaired. The symptoms, or cracking, can be treated only to a point. The white cracks are where the city has tried to seal them with epoxy. (Photograph by author.)

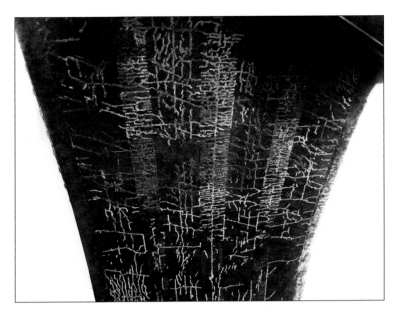

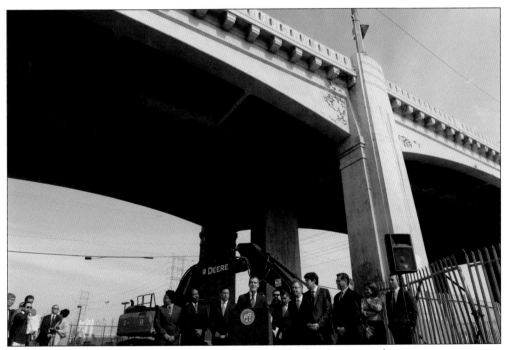

This was not the first news conference on Sixth Street bridge, but it was the most important one. Here, city officials, a congressman, and the new bridge's architect are all together in public for the first time. Perhaps, in about five years' time, there will be another news conference on this spot, underneath the new viaduct. (Photograph by author.)

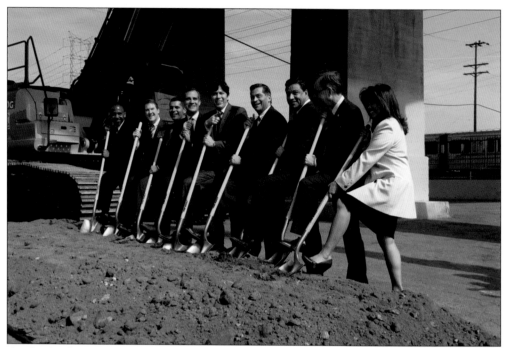

As the Sixth Street Viaduct is looking at demolition in late 2015, the mayor of Los Angeles and other city officials turn over dirt for the ground breaking of the new Sixth Street Viaduct. (Photograph by author.)

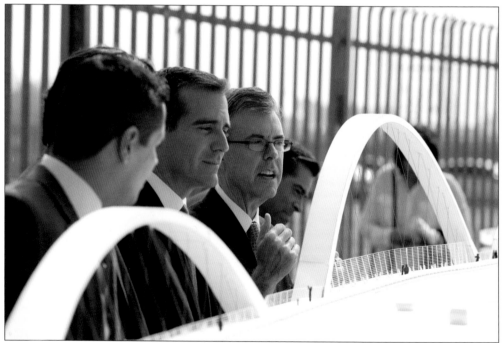

Here, at the ground breaking for the new viaduct, Los Angeles City engineer Gary Lee Moore explains a point on the architectural model of Sixth Street, which is about 40 feet/13 meters in length. Listening is Mayor Garcetti of Los Angeles. (Photograph by author.)

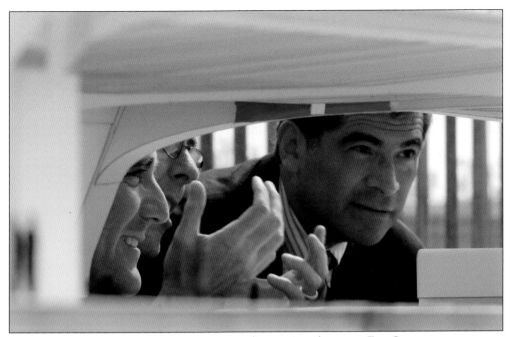

Inspecting the model viaduct are, from left to right, Los Angeles mayor Eric Garcetti, city engineer Gary Lee Moore, and Congressman Xavier Becerra. Congressman Becerra says $380 million of the $420 million budget came from the federal government. (Photograph by author.)

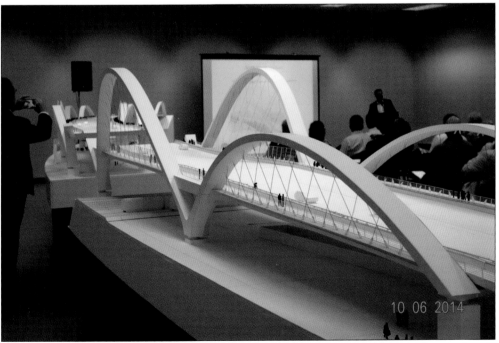

Here is a look at the new bridge. This is only part of the complete model, which stretches 47 feet/14 meters. Local school students from Roosevelt High School built this enormous model. (Photograph by author.)

Here is the new bridge's architect, Michael Maltzan. He also designed the new and controversial One Santa Fe project, just a couple blocks up the road from Sixth Street. He is single-handedly changing the face of the Arts District in Los Angeles. (Photograph by author.)

Seven

OLYMPIC AND WASHINGTON BOULEVARDS VIADUCTS

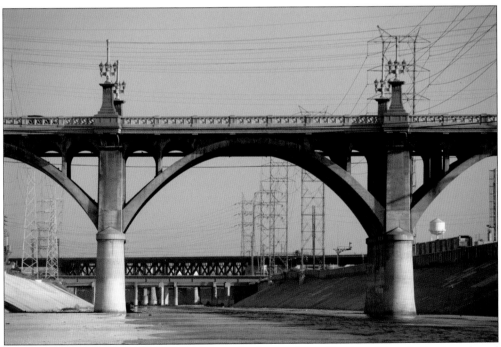

The next few images are of the southernmost bridges in this collection. Olympic Boulevard used to be called Ninth Street but was renamed for the Olympic Games of 1932. This viaduct was built about 1925 and, over the decades, has lost much of its ornamentation. Most, if not all, of the bridge has been restored, and now, it appears as it did almost a century ago. It is also lacking the giant fins seen on many of the other bridge piers. (Photograph by author.)

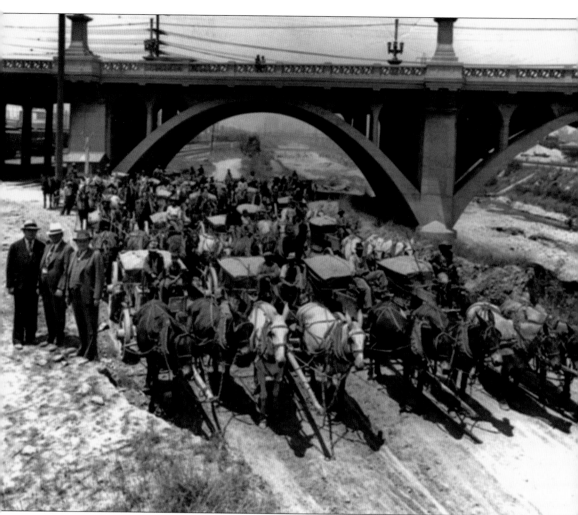

Pictured in front of Olympic Boulevard are many horse-drawn carriages, their drivers, and three men in suits on the left. In the far distance, one can see a faint outline of the Sixth Street bridge, so it can be deduced that, as late as 1932, horses were still working the riverbed. (Courtesy of LAPL.)

Pictured is one of the intricate streetlights of Olympic Boulevard bridge. One of the most ornate of all the bridges, it still has all of its streetlights today. Unfortunately, the power lines are everywhere, and a photograph cannot be taken without also capturing them. At the top of the streetlamp, under the ball, appears to be a flagpole bracket. (Photograph by author.)

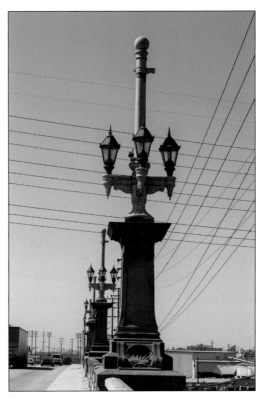

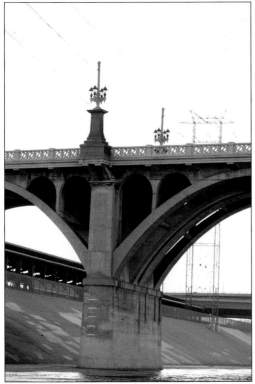

This picture of Olympic Boulevard was taken looking north. One can see the Interstate 10 in the near distance, and beyond that are Seventh and Sixth Streets. (Photograph by author.)

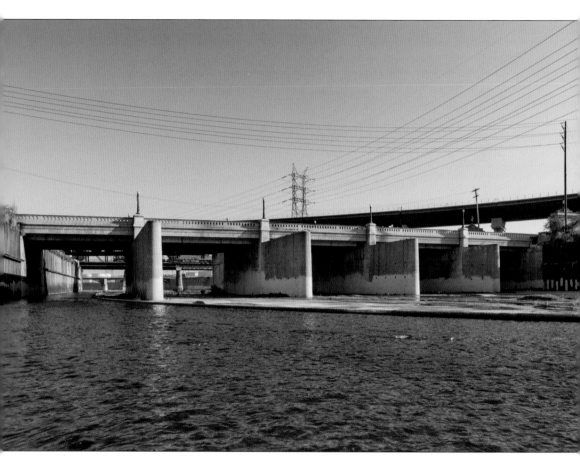

The next few images are of the southern end of this bridge collection; this is Washington Boulevard's bridge. This view shows that Washington Boulevard bridge is small, short, and surrounded by nameless utilitarian bridges. Here, the river is narrower, meaning it must be deeper and faster during storms. Since the river walls are vertical here, there is not as much human intrusion. (Photograph by author.)

This bridge is one of the smallest, like North Main Street, but has something that no other bridge has—friezes memorializing the workmen who made these structures. Fortunately, this frieze was found not long after being repainted; in this area, graffiti is a recurring blight. Was it painted when it was first built? No one knows. (Photograph by author.)

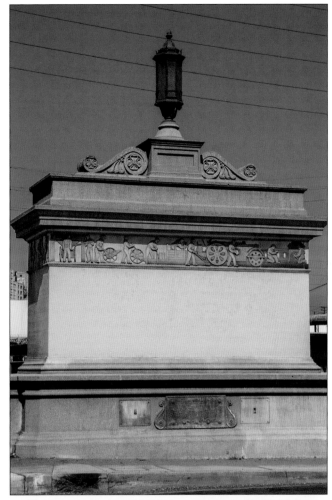

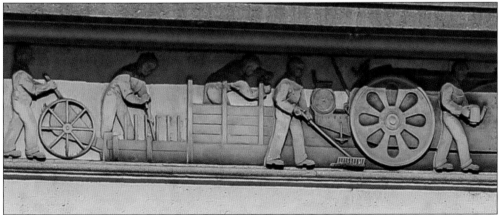

Here is a close-up of the frieze shown above. From the frieze, one can learn that the concrete was carried by wheelbarrows and that workers did have steamrollers but much of the construction seems to have been done by hand. An interesting detail to note is that every worker has his head down. (Photograph by author.)

After city leaders decided to create permanent bridges that could withstand periodic floods, bridge engineer Merrill Butler was hired in 1923. He had found his calling! Butler retired almost 40 years later, in 1961. In the interim, he and his team created more than 200 bridges, of which the river ones are one of the most notable sets in the world. (Courtesy of the Butler family collection.)

Eight

HIDDEN BRIDGES

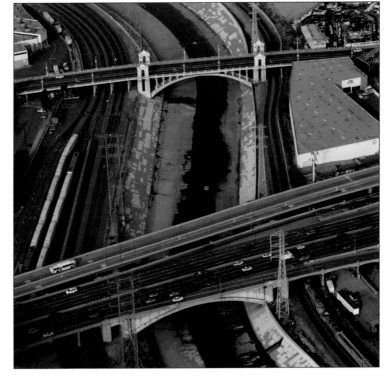

This 2014 aerial view shows Aliso Street bridge, at bottom, and the Macy Street bridge, at top. When looking at the arches that span the river, one can still see the similarities between the two bridges. However, Aliso Street has become just another utilitarian section of the 101 Freeway. (Photograph by author.)

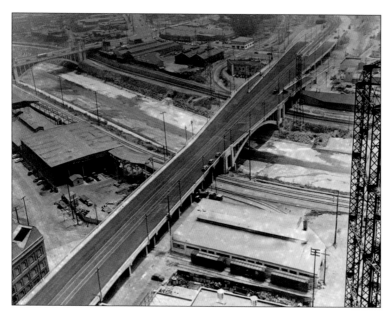

This fascinating view of Aliso and Fourth Streets appears to have been shot from one of the giant oil tanks in the area. Perhaps every structure in this photograph is gone but for the river and the bridges. Of particular interest is the river; the paving appears on the far right of the river, and the bottom appears paved as well. (Courtesy of LAPL.)

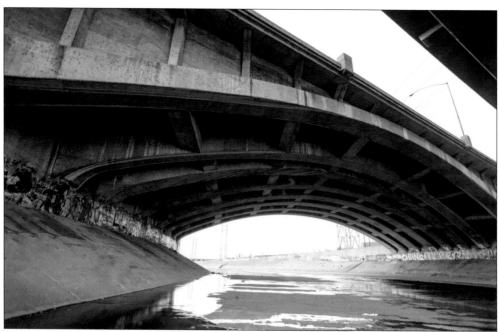

This photograph was taken underneath the 101 Freeway, looking south, under the Aliso Street section. The arch and ribs can be seen in great detail. It is not known why the spandrels are closed. Standing underneath the bridge, one can hear cars and traffic noise but cannot see any vehicles. (Photograph by author.)

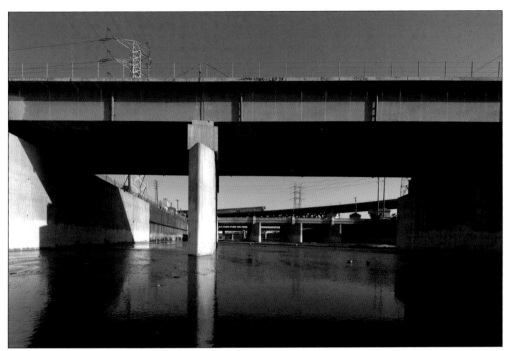

Here is one of several unnamed and anonymous rail bridges over the Los Angeles River. Devoid of any artistic imprint, such as on Washington Boulevard bridge in the background, these utilitarian bridges often pass unremarked. (Photograph by author.)

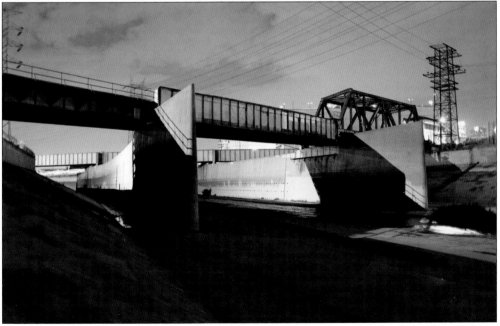

This tiny one-track railroad bridge has the longest fins of all the river bridges; if one follows them to the other end, he or she will find another train bridge! The truss section on the far right is representative of the old truss construction that is all gone, except this piece. (Photograph by author.)

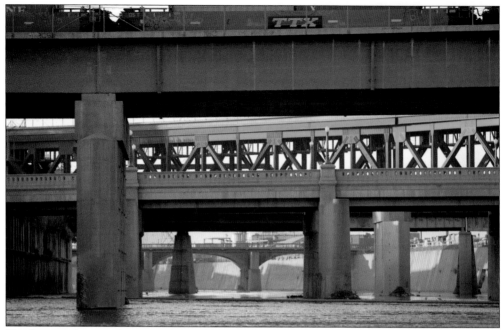

Heading south, past the Interstate 10, this photograph was taken while leaving downtown Los Angeles. Many other types of bridges are shown in this 2007 photograph. The second bridge is Washington Boulevard, which is last on the list for this book. (Photograph by author.)

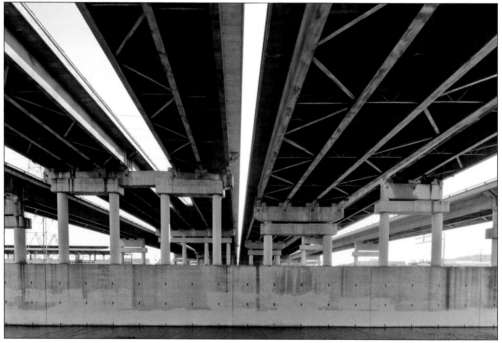

Here is a rarely seen sight, the striking undersides of the Interstate 10 as it approaches the downtown interchange. It is loud and incredibly dusty from the traffic overhead. There appear to be six bridges in this photograph. One can drive this freeway all the way to the East Coast. (Photograph by author.)

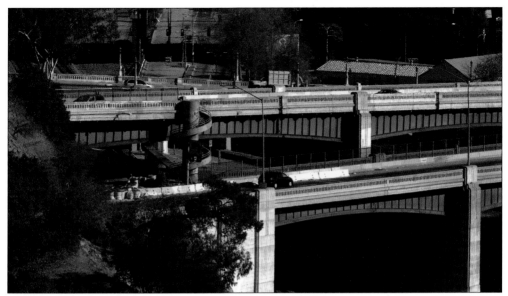

Here is the view of the spiral staircase from one of the adjoining hills and tunnels on the 110 Freeway at Elysian Park. Visible underneath are some of the train tracks, and below them is the Los Angeles River. This 2006 photograph shows the old yellow barrels used for collisions with the stairs, which have been replaced with a modern system. (Photograph by author.)

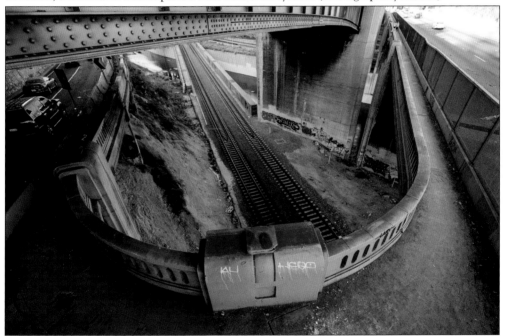

Halfway up the spiral staircase, there is the rush of wind from the 110 Freeway above, going south, and below there is a split from the 110 Freeway North on the right and the connector to the Interstate 5 on the left. Drivers heading north on the Interstate 5 through downtown might recognize this. What many do not know is that from above, one can see downward much, much farther, perhaps 90 feet/30 meters to the riverbed. Also pictured is a pair of busy train tracks, with passenger trains passing every few minutes during rush hour. (Photograph by author.)

Here is a view of the spiral staircase from in the river, late night. Here, three bridges intersect with multiple train tracks, and underneath all is the river. The two large spans are from the 110 Arroyo Seco Parkway, the first freeway in the world. Compare this view to the previous page. (Photograph by author.)

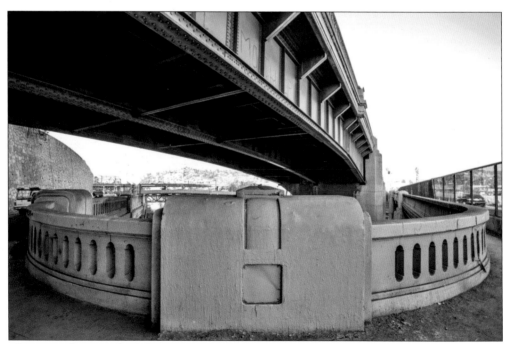

This 2013 photograph of the 110 Freeway South, taken from the base of the stairs, captures a loud, dusty, busy, and intriguing place. (Photograph by author.)

This 2013 view to the south is of the 110 Freeway and its tunnels. As built in the 1940s, traffic moved in the opposite direction. (Photograph by author.)

This 2014 photograph was taken looking north. The freeway to the right was built first, and then years later, a twin was built above center. Just right of center is one of the long-vanished streetlight mounts; it the "bump" on the round wall. Left of center in the back is the old Riverside Drive Viaduct. (Photograph by author.)

Discover Thousands of Local History Books
Featuring Millions of Vintage Images

Arcadia Publishing, the leading local history publisher in the United States, is committed to making history accessible and meaningful through publishing books that celebrate and preserve the heritage of America's people and places.

Find more books like this at
www.arcadiapublishing.com

Search for your hometown history, your old stomping grounds, and even your favorite sports team.

Consistent with our mission to preserve history on a local level, this book was printed in South Carolina on American-made paper and manufactured entirely in the United States. Products carrying the accredited Forest Stewardship Council (FSC) label are printed on 100 percent FSC-certified paper.

MADE IN THE